Remembering
The Gateway Arch

NiNi Harris

TURNER

PUBLISHING COMPANY

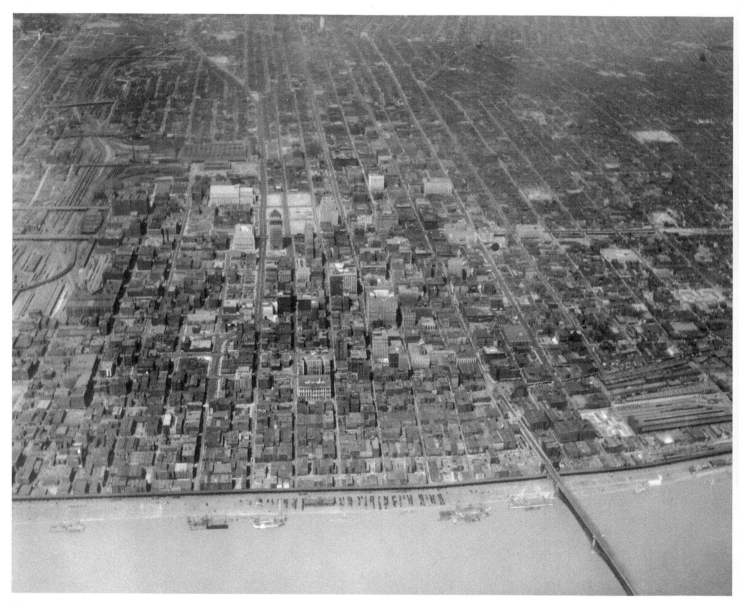

The campaign to establish a riverfront memorial honoring Thomas Jefferson for his vision of an expansive United States and the story this riverfront acreage played in America's westward expansion began in 1933. "Aeroplane" views of the old riverfront were used to sell the concept of creating the first national memorial to Thomas Jefferson. (The Jefferson Memorial in Washington, D.C., would not be dedicated until 1943.)

Remembering
The Gateway Arch

Turner Publishing Company
www.turnerpublishing.com

Remembering the Gateway Arch

Library of Congress Control Number: 2010932637

ISBN: 978-1-59652-711-9

Printed in the United States of America

ISBN 978-1-68336-891-5 (pbk.)

CONTENTS

ACKNOWLEDGMENTS...VII

PREFACE...VIII

GROUND OF IMMEASURABLE SIGNIFICANCE
 (1840s–1940s)..1

DESIGNING THE MONUMENT
 (1947)...25

ARCH OBSTACLES
 (1948–1959)..35

A MONUMENTAL CONSTRUCTION PROJECT
 (1960–1967)..43

SYMBOL OF OPTIMISM AND UNITY
 (1968–1970s)..89

NOTES ON THE PHOTOGRAPHS...131

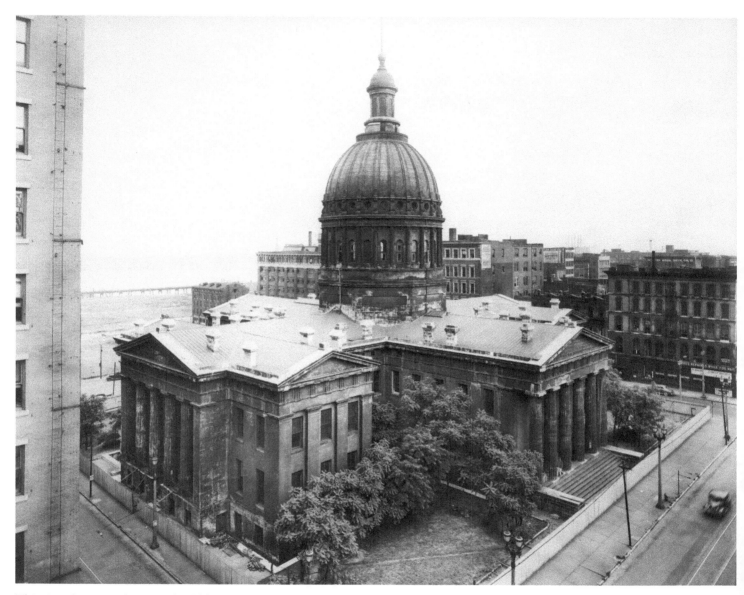

This view facing southeast to the Old Court House shows nineteenth-century buildings in the background, and the cleared riverfront, railroad trestle, and river to the left. In 1930, the city courts moved from the grand, domed, nineteenth-century courthouse to the new, larger, Civil Courts Building. The courthouse then became home to civic and cultural groups. In 1940, the National Park Service took ownership of the building as part of the Jefferson National Expansion Memorial. The Park Service began an authentic restoration of the venerable structure.

Acknowledgments

This volume, *Remembering the Gateway Arch,* is the result of the cooperation and efforts of many individuals and organizations. It is with great thanks that we acknowledge the valuable contribution of the National Park Service, Jefferson National Expansion Memorial, for their generous support.

We would also like to thank the following individuals for valuable contributions and assistance in making this work possible:

Bob Moore, Historian, Jefferson National Expansion Memorial, Department of the Interior
Jennifer R. Clark, C.A., Archivist, Jefferson National Expansion Memorial
Thomas Dewey, Librarian, Jefferson National Expansion Memorial
Kathleen Moenster, Assistant Curator, Jefferson National Expansion Memorial

———————

With the exception of touching up imperfections that have accrued with the passage of time and cropping where necessary, no changes to the photographs have been made. The focus and clarity of many images is limited to the technology and the ability of the photographer at the time they were taken.

PREFACE

The Gateway Arch reflects the history of tens of thousands of Americans for whom the St. Louis riverfront served as a funnel on their way to making the United States a nation that stretched from the Atlantic to the Pacific. The St. Louis riverfront witnessed early trade with the Indians, the rise of steamboat traffic on the western rivers, the settlers beginning their long journeys west by wagon, and the transcontinental railroad linking one coast of the United States to the other.

In 1933, St. Louisans first envisioned a memorial to commemorate the unparalleled role of their riverfront in the opening of the American frontier. Ninety acres of riverfront were designated the site of what was to be called the Jefferson National Expansion Memorial. The memorial would honor both the westward migration and President Thomas Jefferson, who had the vision to expand the nation's territory west of the Mississippi River with the Louisiana Purchase. The focal point of the site was to be an awe-inspiring monument.

Civic leaders wanted a monument that would symbolize the story of all American pioneers who had gone west. Some proposals mimicked traditional architectural models. Others were period pieces of the post–World War II era. One design, proposed by an American architect born in Finland, embodied symbolism that is direct, convincing, and timeless.

Eero Saarinen proposed an arch of welded, triangular, stainless-steel sections towering 630 feet over the grounds of the historic riverfront. Saarinen's design won the day. Construction of what is today known as the Gateway Arch began in 1962. Its engineering was audacious. Its construction workers, whose work site often dangled in midair, courageous.

From its conception to its dedication, the riverfront monument was three and a half decades in the making. It was first dreamed of at the beginning of the Great Depression. Through economic hardships, through wars, and through attempted and successful assassinations of American leaders, the city of St. Louis and the National Park Service kept planning, designing, engineering, and building the monument. The completed Gateway Arch achieved what Saarinen stated was a purpose of architecture, "To fulfill [man's] belief in the nobility of his existence."

—NiNi Harris

President Thomas Jefferson's Louisiana Purchase in 1803 slowly transformed St. Louis from a French fur-trading post into the staging area for the westward expansion of the United States. This frontispiece from the St. Louis City Directory of 1859—showing the busy riverfront, a paddlewheel riverboat, a train engine, and the Old Court House—illustrates the story memorialized by the Gateway Arch.

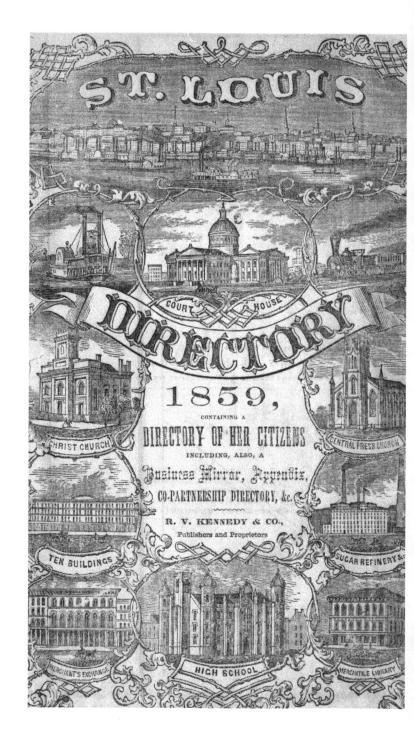

Ground of Immeasurable Significance

(1840s–1940s)

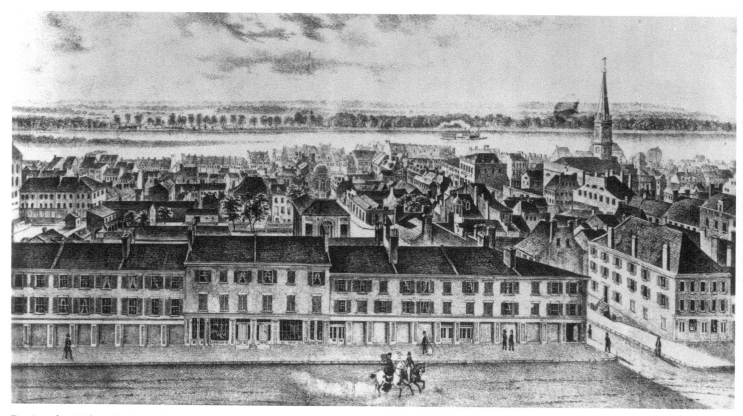

During the 1840s, St. Louis boomed. Waves of potato-famine Irish and German revolutionaries debarked from riverboats on the St. Louis levee. Many decided to stay and build homes and communities in this city poised on the edge of the frontier. St. Louis more than quadrupled, with its population growing from 16,469 at the beginning of the decade to more than 74,000 in 1850.

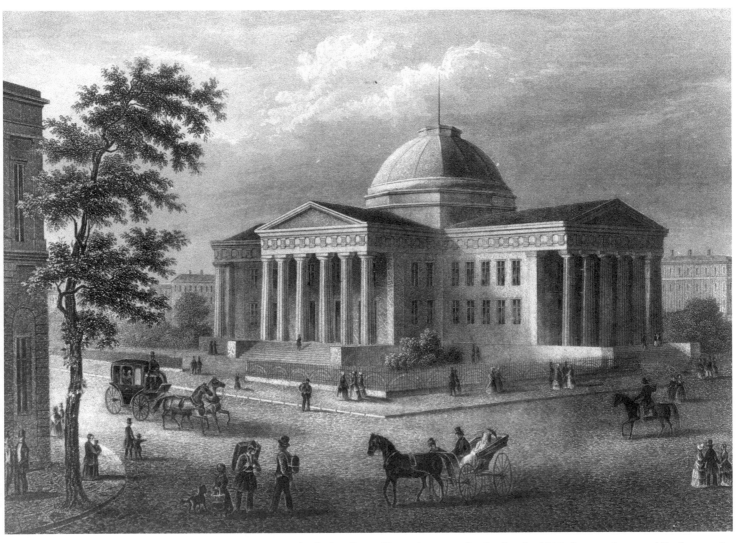

St. Louisans built the Court House in stages, beginning in 1839. It served as a public forum. St. Louisans honored hometown volunteers returning from the War with Mexico at the courthouse. The Dred Scott Case, which forced the debate over slavery all the way to the U.S. Supreme Court, was first brought to trial in its courtrooms. This illustration appeared in one of many German publications featuring St. Louis and Missouri.

The Renaissance-style, cast-iron dome of the Court House was completed in 1861, while the dome of the U.S. Capitol was under construction. Situated on high ground, it provided a natural reviewing stand for military parades. The Court House had been the site of a spirited debate in 1849 over building a transcontinental railroad. It was here also that Missouri senator Thomas Hart Benton uttered the poetic phrase encouraging national expansion, "Westward the course of Empire."

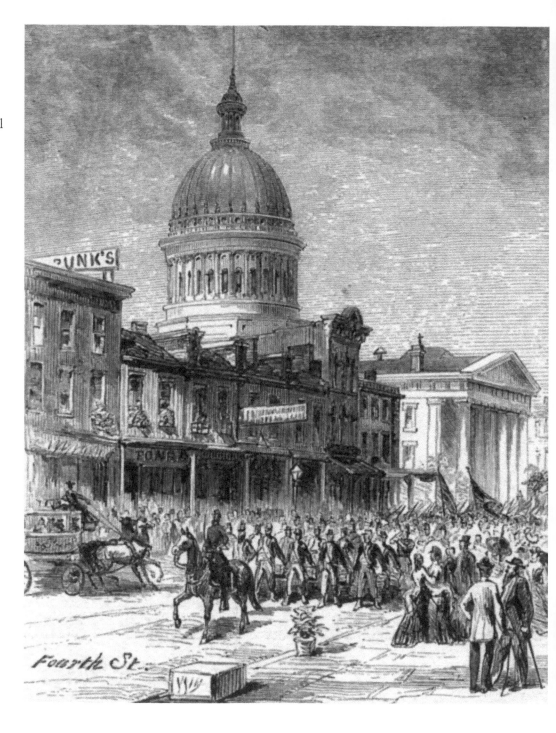

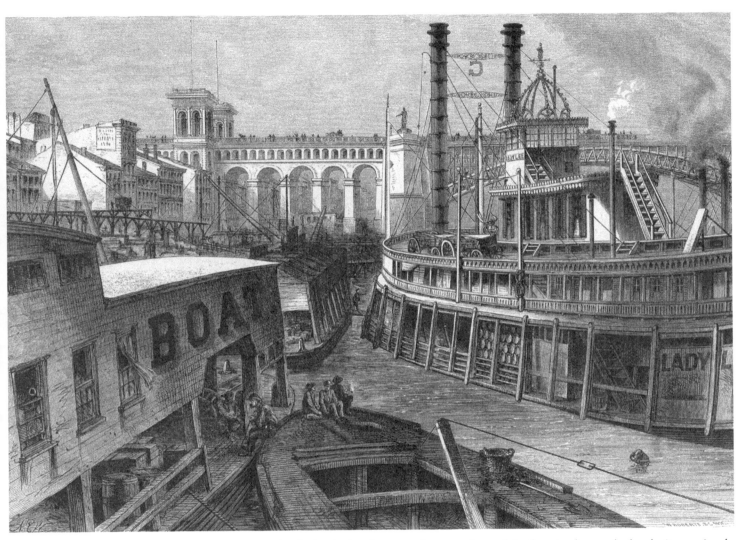

For a century the St. Louis riverfront was the emporium of the frontier, but to the locals, it was simply the busiest place in town. Riverboats lined its levee. Mountains of crates, bales, and barrels turned the levee into an obstacle course for teamsters, draft horses, and wagons. The Eads Bridge, opened in 1874, gradually moved commerce away from the riverfront, to stations and warehouses lining the railroad tracks.

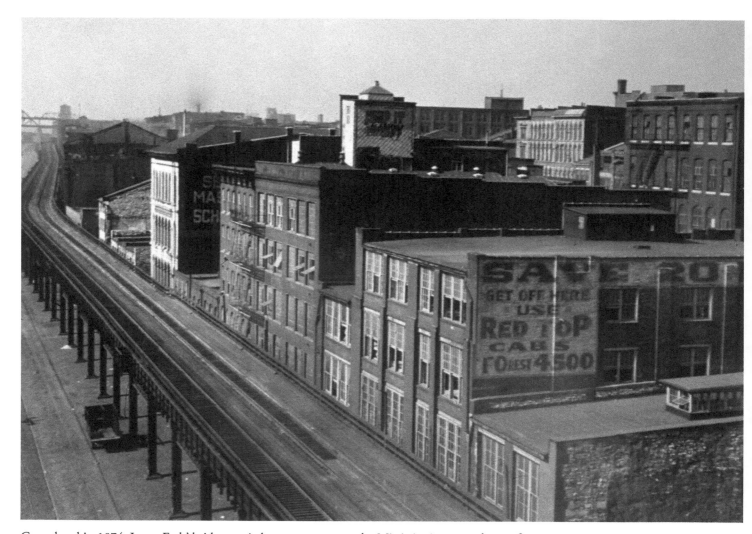

Completed in 1874, James Eads' bridge carried commerce across the Mississippi, over and away from the levee warehouses. Adding to the mischief, from the 1880s forward the elevated railroad along the levee spewed smoke and coal dust into the historic buildings. By the 1930s, the riverfront's brick-and-stone commercial buildings, which had powered America's westward expansion, stood neglected, underused, or vacant. A small artistic community, including night spots named Little Bohemia and the Blue Lantern, would find a home in this cheap-rent district.

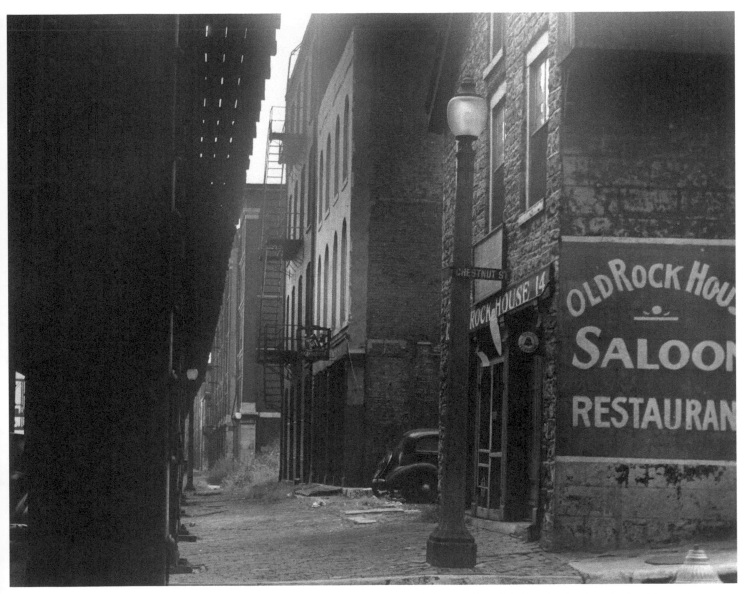

Fur trader Manuel Lisa used the stone of the riverfront bluffs at St. Louis to build this warehouse on Wharf Street in 1818. Years later, local banker James Clemens, Jr., cousin of Mark Twain, bought the warehouse. During the early twentieth century, under the shadow of the elevated tracks, the building housed a tavern, dance hall, and the tavern-keeper's living quarters.

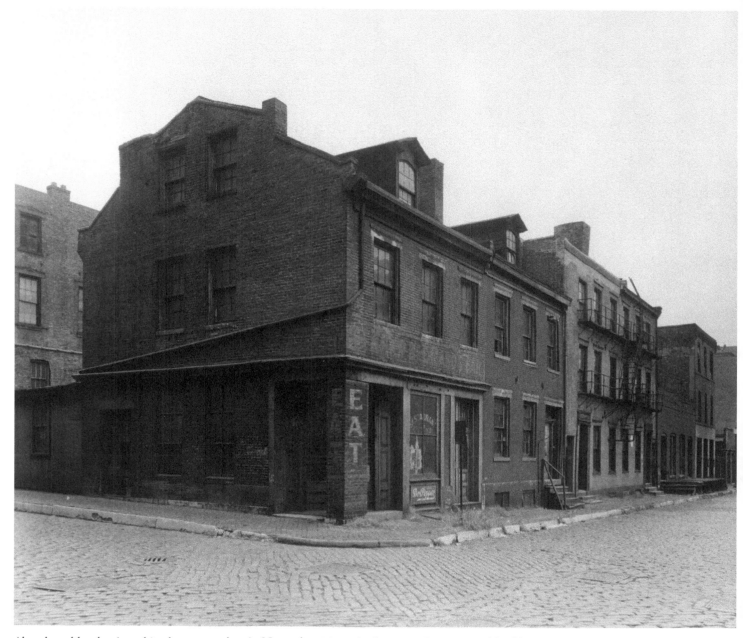

Abandoned by the time this photo was taken in November 1939, the homes and commercial buildings on the northeast corner of First and Elm streets once provided Americans heading west with supplies, food, and temporary lodging.

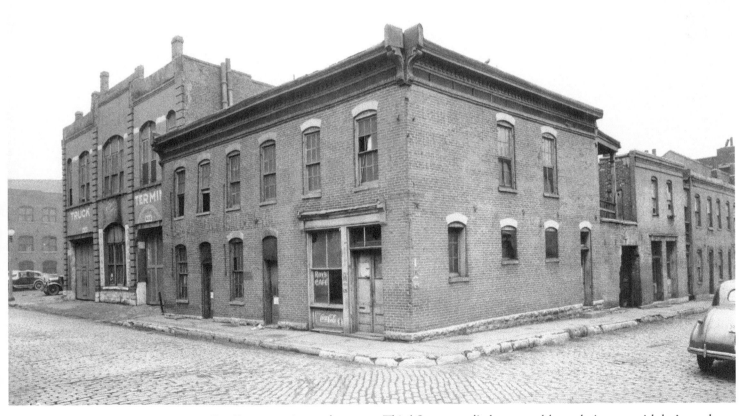

Small concerns in warehouses on Third Street supplied westward-bound pioneers with knives, plows, traps, kettles, rope, canvas, dishes, fabric, coffee, spices, and all the provisions needed for a six-month journey by covered wagon.

After a raging fire devastated many blocks
of the riverfront district in 1849, new
construction including the Michael Building,
which stood on North First Street, rose along
the narrow streets leading from the busy levee.
Ornate cast-iron lintels topped each window
on this small commercial structure, which
served as the office of the Great Southern
Overland Mail in 1858.

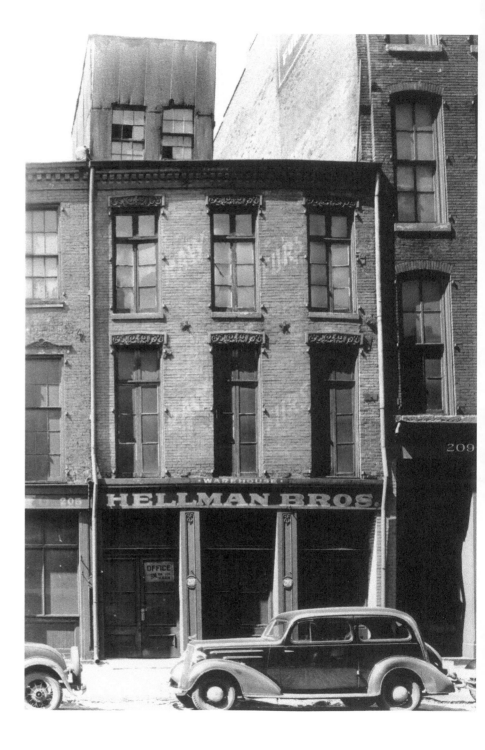

During the 1850s and 1860s, commercial palaces replaced the earlier, more primitive riverfront buildings, many of which had burned. The Garnier Building on South First Street featured an intricate cornice and lintels in the Italianate style.

Elaborate cast-iron columns and rows of Roman arches made this wholesale house on First Street a work of art. Thomas Walsh, an Irish-born St. Louis architect, designed this building in 1858.

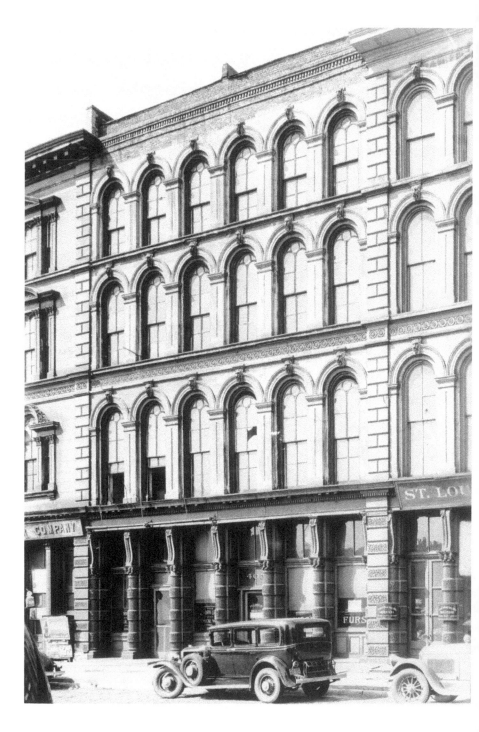

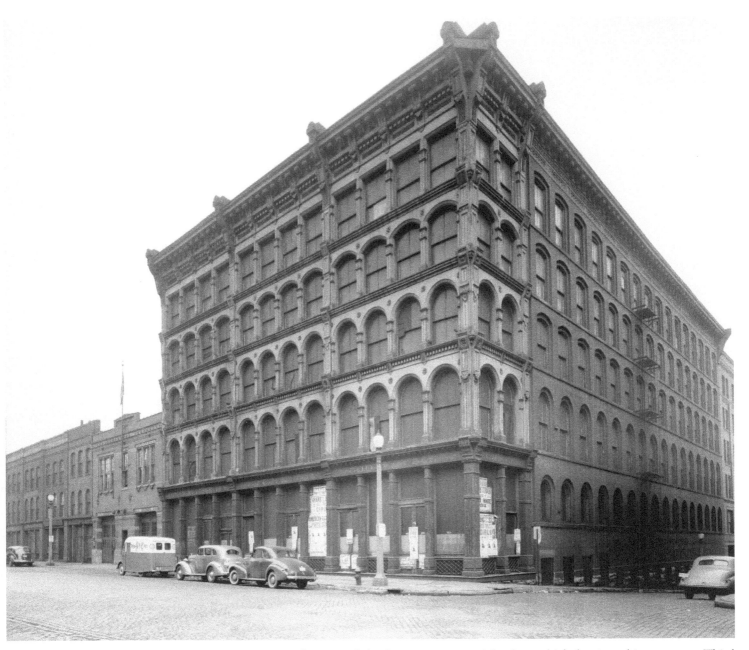

A cornice with an exotic flair topped this five-story commercial palace, which dominated its corner on Third Street. The facade features windows of several designs, including flat, eyebrow, and Roman-style arches.

The elevated railroad tracks hid much of the simple, yet elegant facade of the Boatman's Exchange Building, constructed on Wharf Street in 1868.

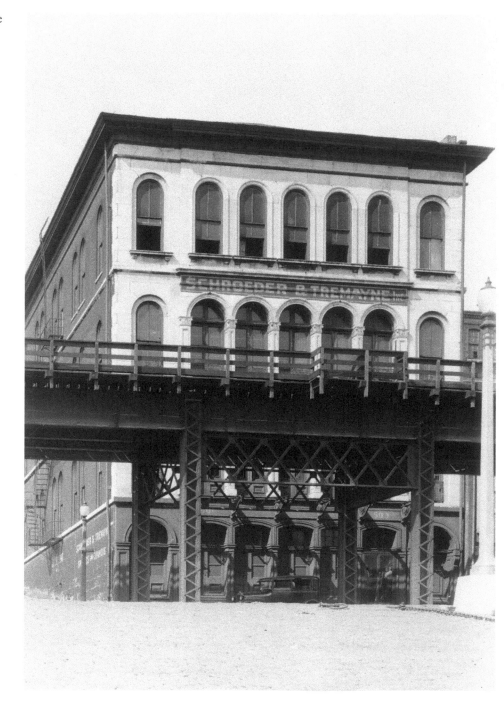

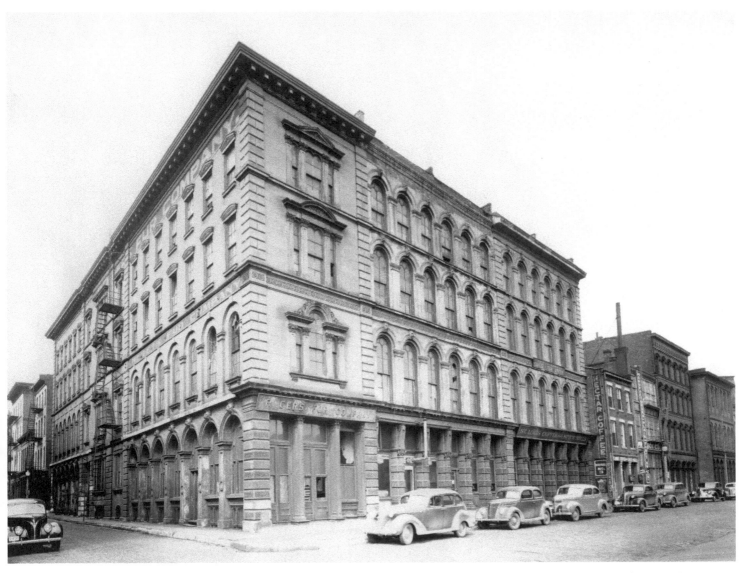

The booming steamboat traffic of the 1850s spurred prosperity on St. Louis' riverfront. Built in 1858, this grand bank building reflected that prosperity. Late in the decade, a youthful Samuel Langhorne Clemens earned his license to begin a brief career as a Mississippi River steamboat pilot. Although the Civil War would spur Clemens to leave the river, he never abandoned his nostalgia for it, which he recounted in *Life on the Mississippi* and other literary works as Mark Twain. The pen name itself alluded to the river—"mark twain" was the boatman's call of two fathoms, or twelve feet, in depth.

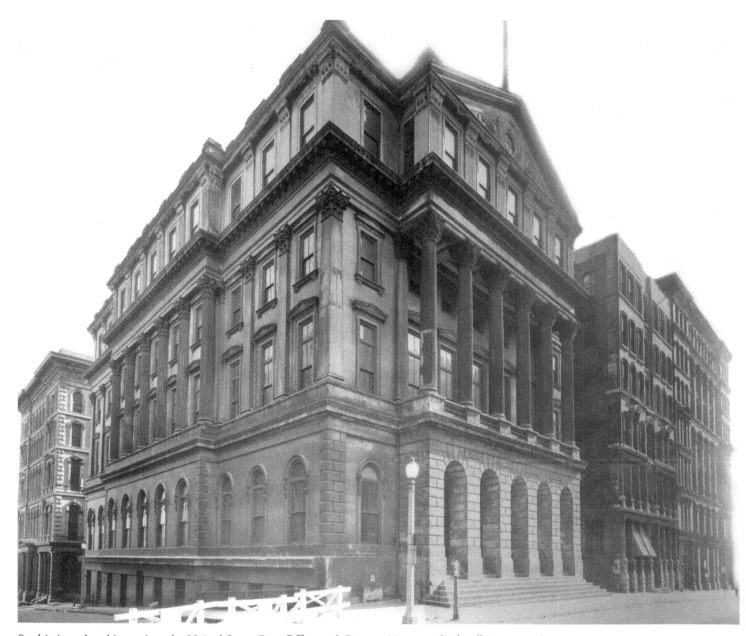

Sophisticated and imposing, the United States Post Office and Custom House undoubtedly impressed St. Louisans as well as those passing through St. Louis on their way to the frontier. Begun in 1852 and completed in 1859, the structure was originally three stories, with a fourth floor added in the 1880s.

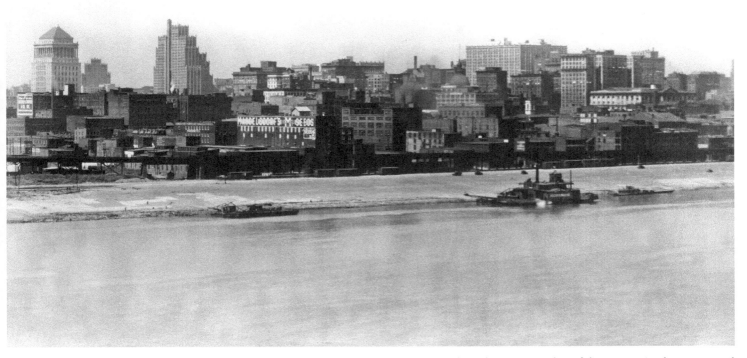

New high-rise buildings were being constructed on the western edge of downtown in the 1920s and 1930s, away from the river. The historic riverfront was seen as decaying and blighted. Ironically, to memorialize what had happened on the riverfront within many of the buildings there, civic leaders decided to raze them. Some envisioned reforesting the area, to give it the appearance early settlers saw.

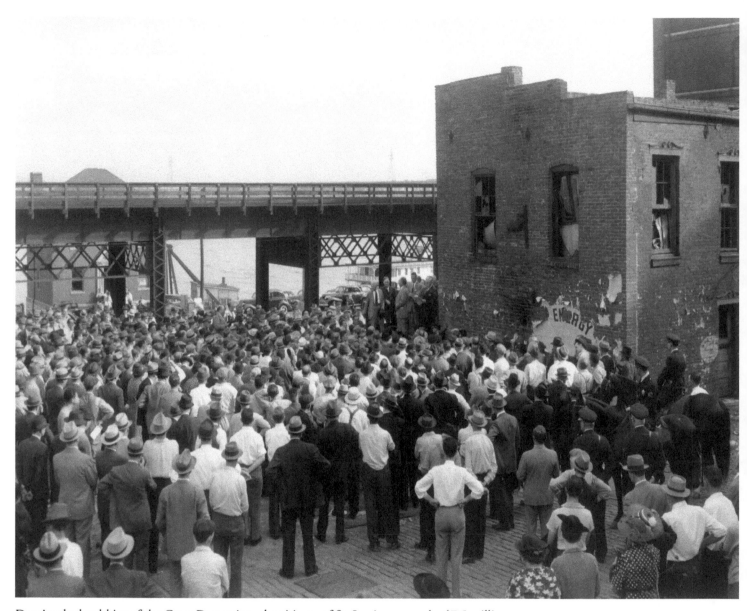

Despite the hardships of the Great Depression, the citizens of St. Louis approved a $7.5 million bond issue to fund the creation of a great memorial. The Works Progress Administration, a federal depression-era employment program, would channel funds to cover the remaining costs. This crowd gathers on the levee on October 10, 1939, to hear speeches and enjoy hoopla surrounding the beginning of demolition of the riverfront buildings.

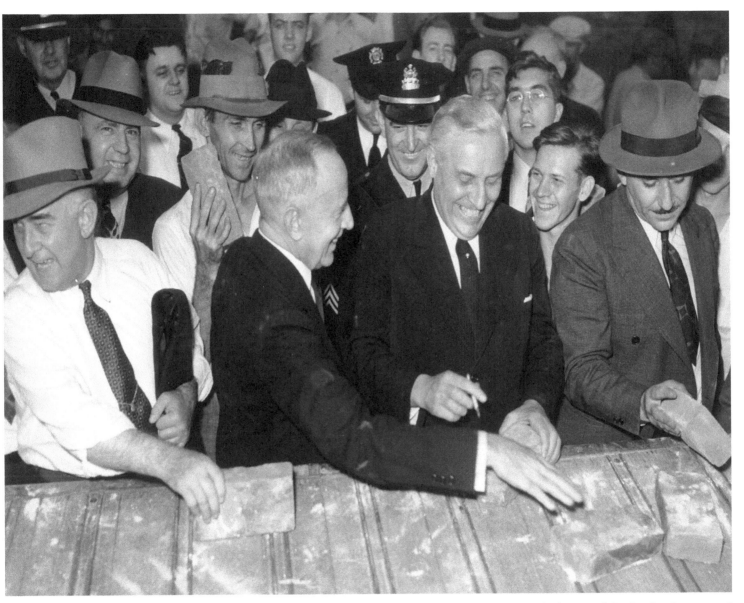

As part of the ceremony, Mayor Bernard F. Dickmann autographed some of the first bricks removed from a building at Wharf and Market streets. Jubilant onlookers in this image know the project means jobs for locals. This day of celebration took place only weeks after Nazi Germany invaded Poland, signaling the start of World War II.

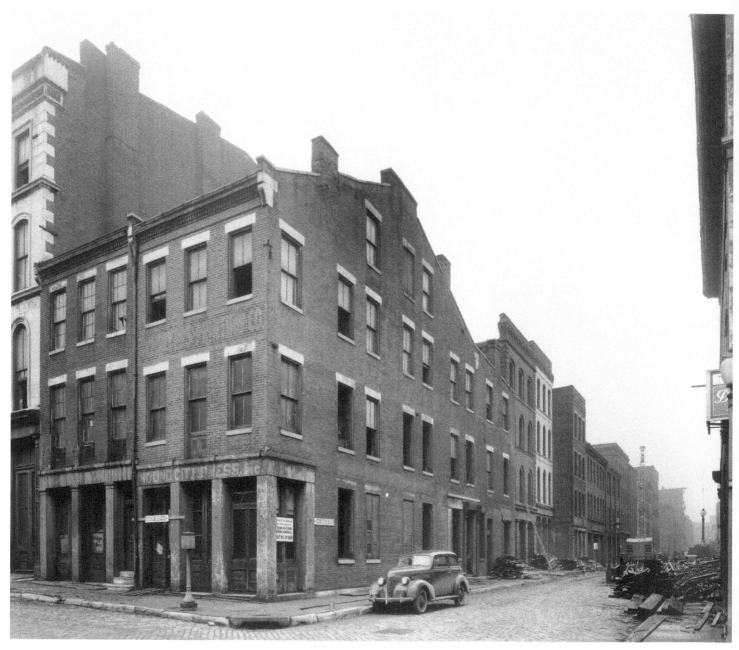

Demolition debris filled many of the cobble streets of the riverfront by the time this image was recorded in February 1940.

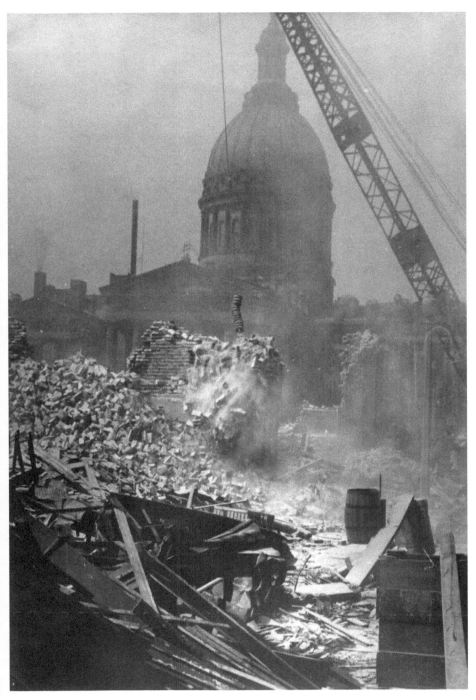

The Old Courthouse stands witness from behind as a wrecking ball obliterates the wood, brick, and iron of the old warehouses lining the brick walks and stone curbs.

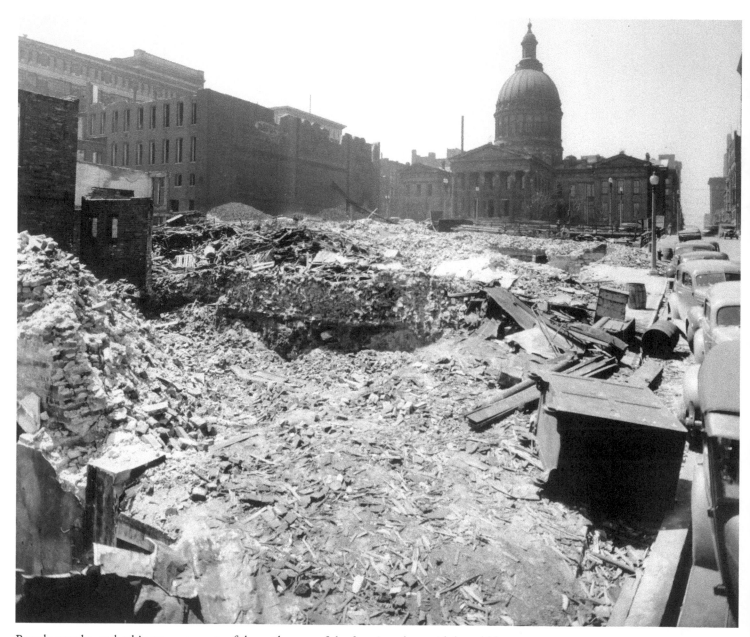

Barrels, trunks, and cabinets—remnants of the settlement of the frontier—lay amid the rubble on the blocks cleared to create Luther Ely Smith Square, connecting the Memorial grounds with the Old Courthouse. More than 500 buildings were erased to make way for the new memorial.

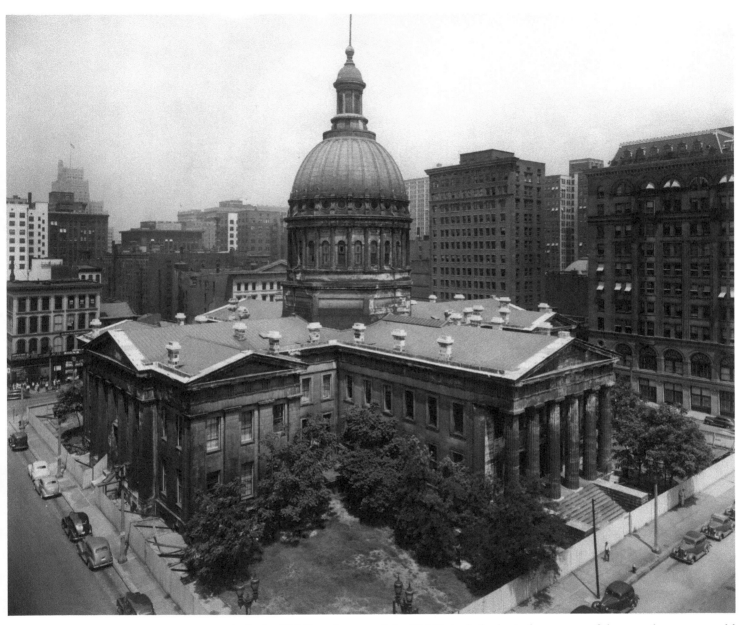

Only the Old Courthouse and the Old Cathedral, physical remnants of the steamboat era, would remain standing on the grounds of the memorial. Some citizens nonetheless maintained that the downtown area retained an abundance, even surplus, of nineteenth-century buildings, as evidenced here by the density of the buildings on the other three sides of the courthouse.

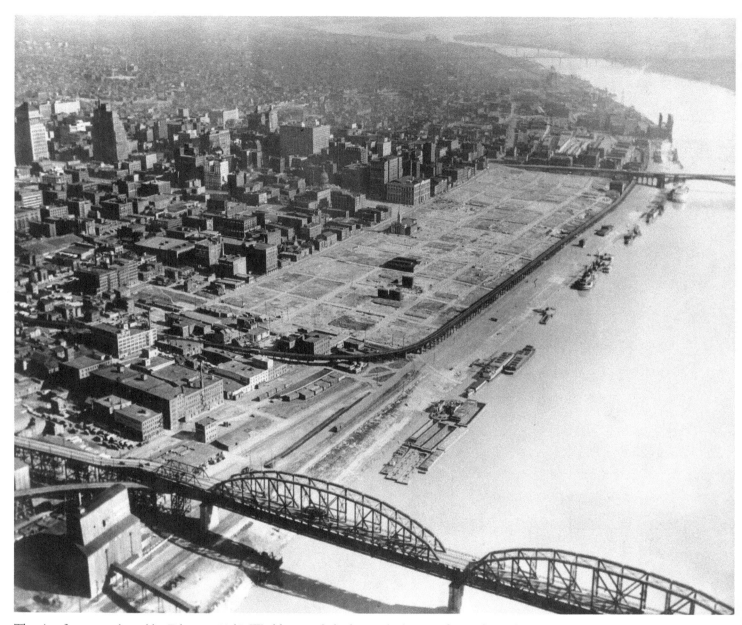

The riverfront was cleared by February 1942. World events halted even the luxury of considering how to create a memorial. France had fallen, England was weathering the Nazis' rain of bombs, and Japan had attacked the United States Navy at Pearl Harbor. A world war would have to be won before St. Louisans could again contemplate creating a monument that would rise to its purpose.

DESIGNING THE MONUMENT

(1947)

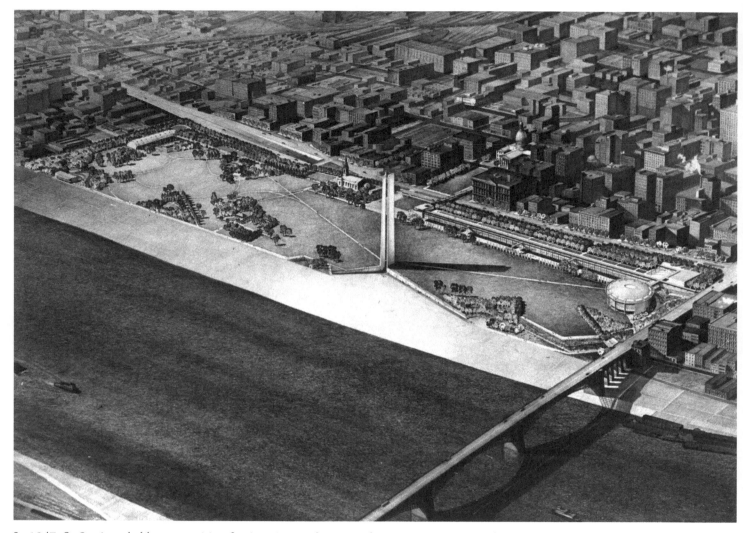

In 1947, St. Louisans held a competition for American architects to design an inspiring riverfront memorial. Several of the 172 entries in the competition to design the Jefferson National Expansion Memorial featured futuristic versions of an obelisk or spire as the central feature. The New York–based firm of William N. Breger, Caleb Hornbostel, and George S. Lewis designed a monument situated at river's edge, depicted in this architectural rendering. The monument consisted of towering twin pylons, with a winged base. The pylons were to be made of reinforced concrete faced with native marble. The narrow, funnel-like opening between the pylons was accentuated by curves in the pylon walls. The design attempted to symbolize the role of the St. Louis riverfront in funneling westward expansion.

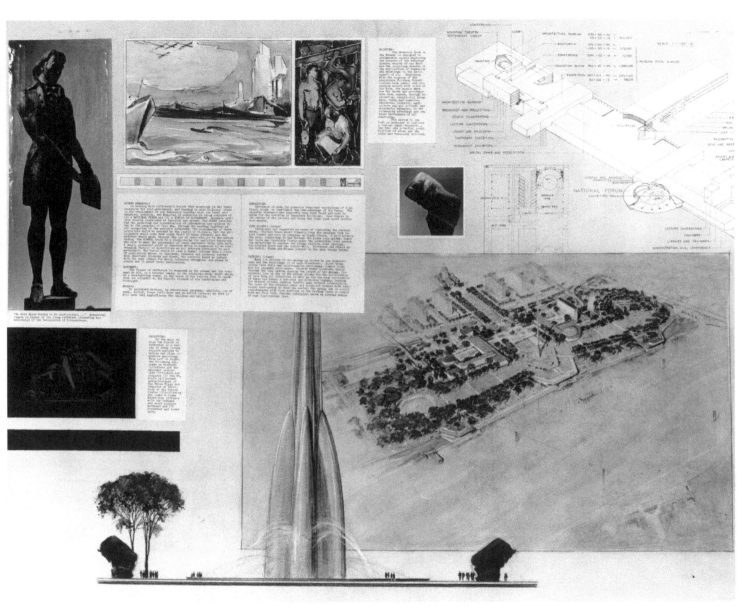

The proposal entered by Roger Bailey, who was a professor of architecture at the University of Michigan, featured an obelisk that appeared similar to a rocket at lift-off, with fountains to simulate the exhaust swelling at its base. Bailey suggested linking the east bank of the Mississippi to the St. Louis side using cable cars.

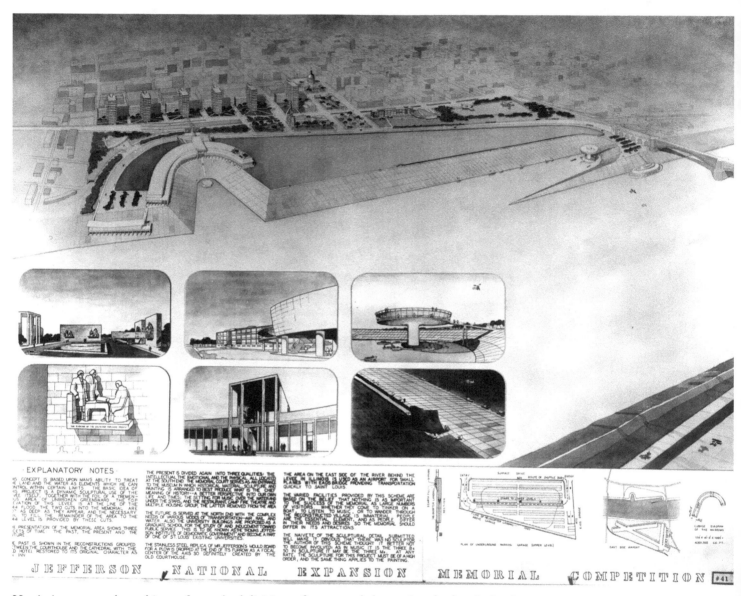

JEFFERSON NATIONAL EXPANSION MEMORIAL COMPETITION #41

Harris Armstrong, the architect of several subdivisions of avant-garde homes in suburban St. Louis during the 1950s, proposed redesigning the Mississippi levee itself. His plan cut into the bluff, creating an artificial slough with an observation deck that looked like a flying saucer.

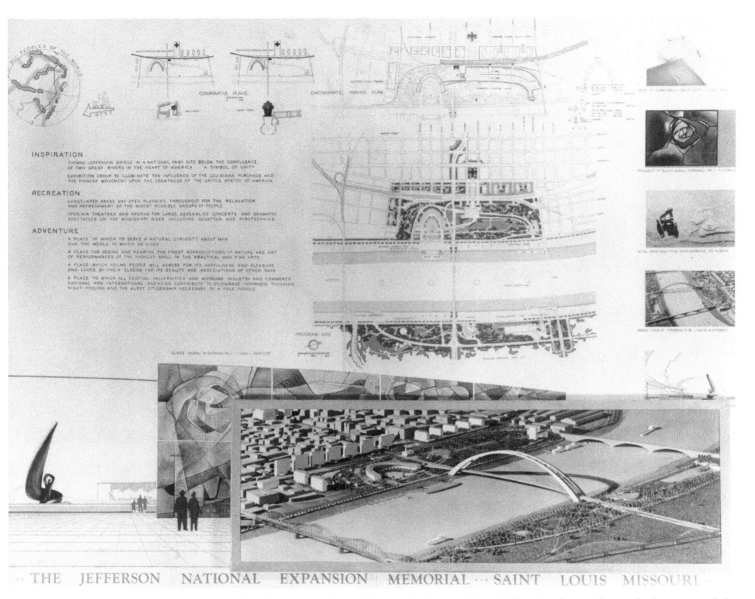

Leading St. Louis architects Eugene Mackey and Joseph Murphy designed an arch that spanned the Mississippi, tying forested grounds on the Illinois bank with a semicircular museum building, and an obelisk on axis with the Old Courthouse. A few years after the competition, Murphy designed the Resurrection Roman Catholic Church in St. Louis City, with a floor plan in the shape of a parabolic arch.

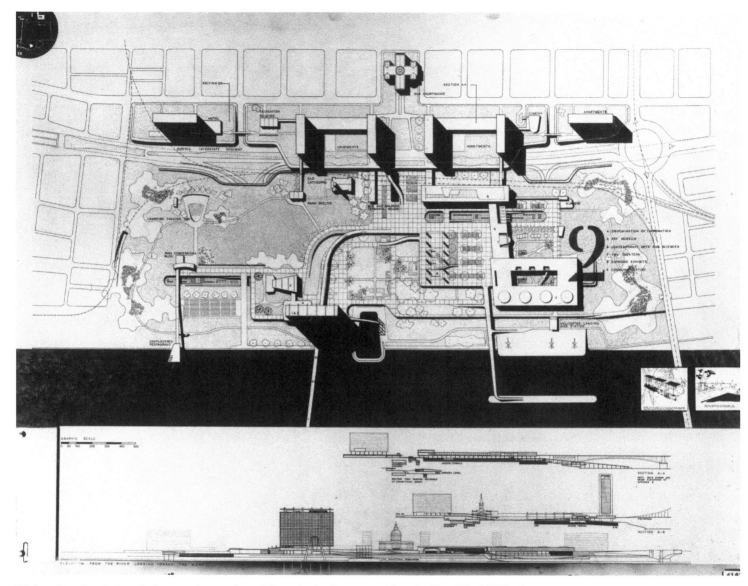

Walter Gropius designed elegant, glass-and-steel factories in Germany. After the First World War, he merged two German institutions to form the Bauhaus, transforming twentieth-century architecture. Following Hitler's rise to power, Gropius left Germany, and later, with a number of young American architects, founded the Architects' Collaborative. A high-rise on stilts at river's edge and a restaurant cantilevered over the water were key components of their riverfront memorial plan for St. Louis.

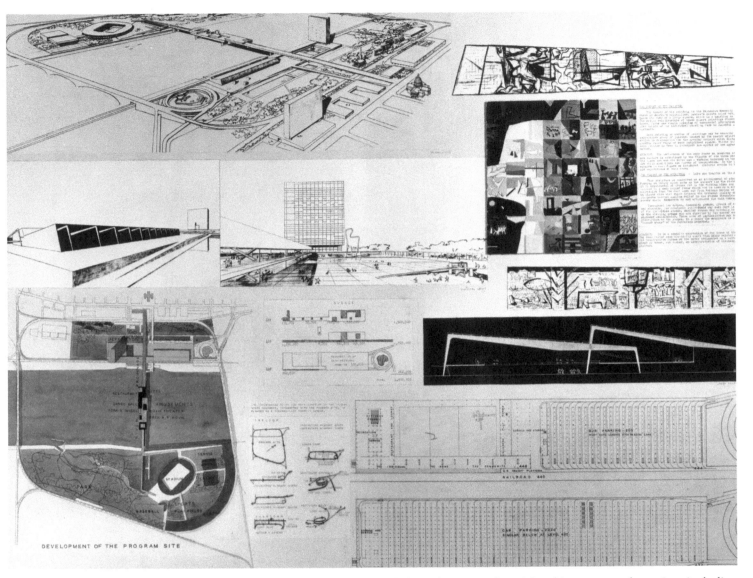

DEVELOPMENT OF THE PROGRAM SITE

The prestigious project drew proposals from the most influential architects across the nation, including Skidmore, Owings & Merrill, Walter Gropius, Eliel Saarinen, Charles Eames, Edward D. Stone, Kazumi Adachi, Frederick Dunn, and Louis Kahn. Dunn pioneered modern architecture in St. Louis before he entered the Navy during World War II. His concept for the riverfront memorial included reshaping the levee to create a setting for a huge waterfall. Louis Isadore Kahn, Baltic-born and American-raised, proposed a design that included features on both riverbanks, tied together by a bridge-like memorial.

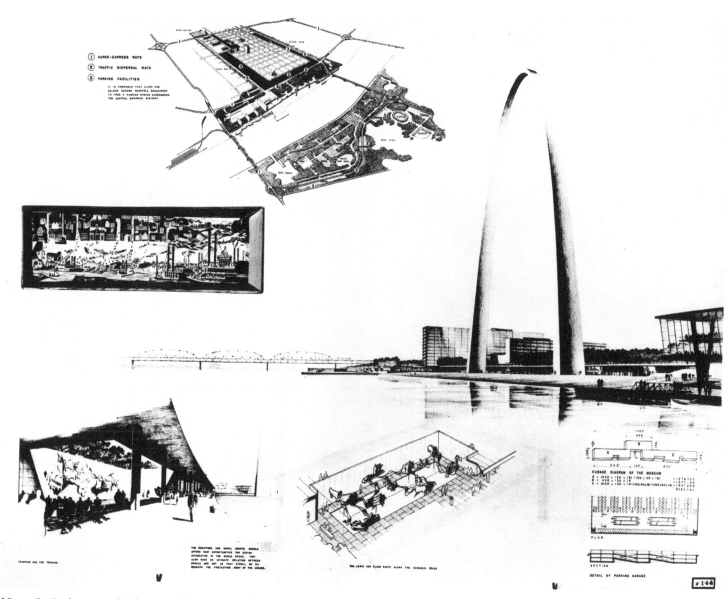

Harry B. Richman, a third-year architecture student at St. Louis' Washington University, volunteered to unpack and display the entries in the anonymous competition for review by the judges. "Opening every crate, every package was a thrill," Richman stated. "There were a number of very fine entries. By comparison to the Arch, they were fairly conventional."

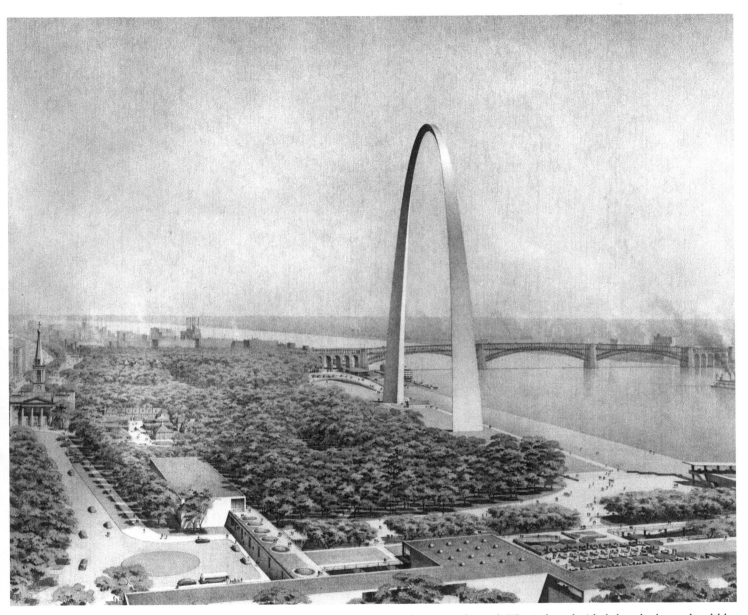

"The Arch was decisively different," Richman proclaimed. The judges decided that the levee should be preserved, and that bridging the river for the memorial would be inappropriate. Those criteria helped eliminate scores of entries. Then each judge voted for entries with merit, narrowing the field to 15. The judges voted by secret ballot for the last 15. Richman remembered, "Saarinen was always in the lead."

After finishing his studies at Yale
University, Eero Saarinen worked
as a partner to his father, Eliel
Saarinen, in Bloomfield Hills,
Michigan. Eliel was one of the
great modern architects of Europe,
when he won second prize for his
proposal for the Chicago Tribune
skyscraper in 1922 and emigrated
from Finland to the United States.
The father and son, Eliel and
Eero, entered competing plans for
the St. Louis riverfront memorial.
Eero was only 38 years old when
he proposed the Gateway Arch.

Arch Obstacles

(1948–1959)

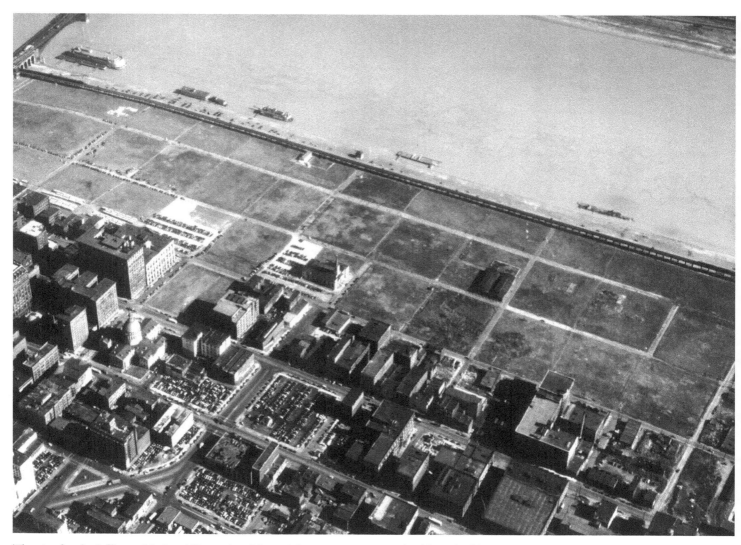

The site for the Jefferson National Expansion Memorial sat empty. Its great buildings had been razed, but the grid of streets that had been home to early St. Louisans and pioneer merchants still crisscrossed its 90 acres.

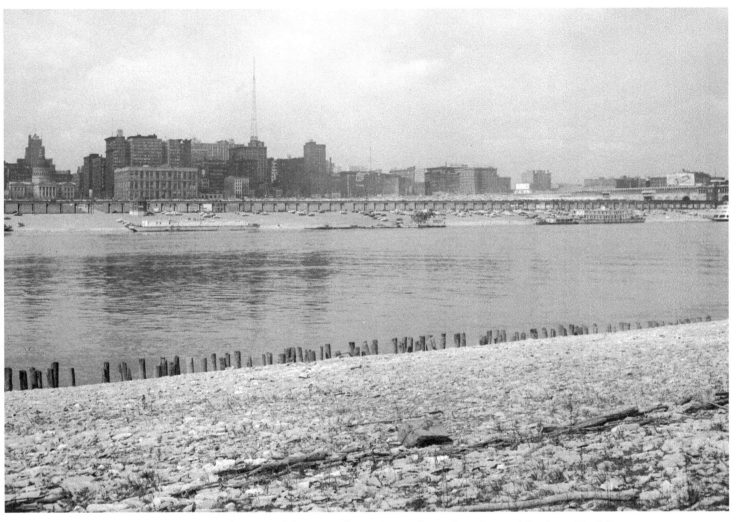

This view of the empty St. Louis riverfront, cleared in anticipation of building a great monument, recalls a verse by early-twentieth-century St. Louis poet Sara Teasdale:

"Hushed in the smoky haze of summer sunset,
When I came home again from far-off places,
How many times I saw my western city
Dream by her river."

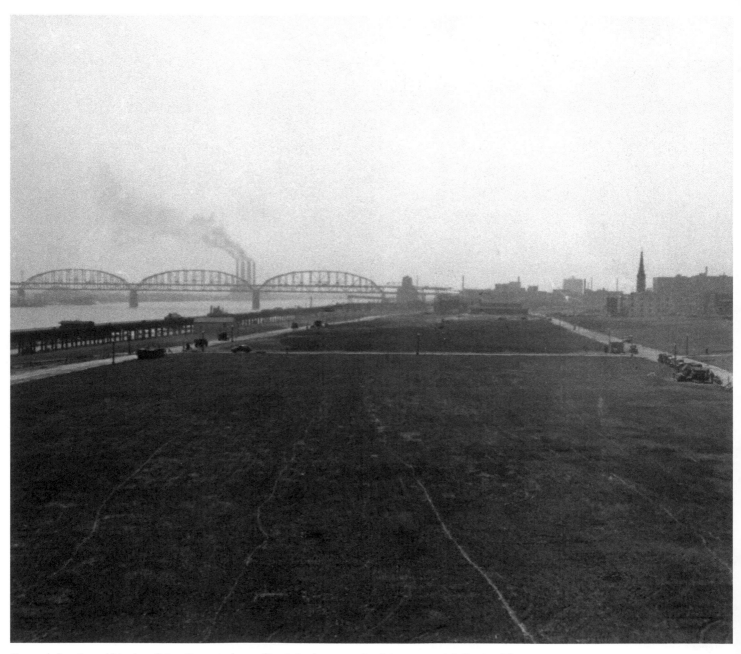

Beyond the cleared blocks of riverfront, industry lined the levee south of the memorial district. The Municipal Bridge, smokestacks, and the elevated railroad trestle framed the view.

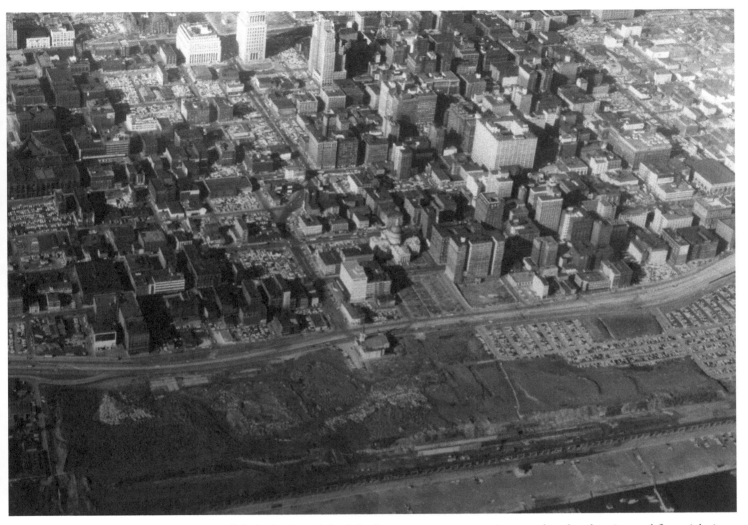

While St. Louis and the federal government were putting together the planning and financial pieces to create the memorial, life-styles and transportation were changing. The increased number and use of automobiles created pressure on St. Louis' crowded downtown. The city temporarily put more and more of the vacant acreage to use as a municipal parking lot.

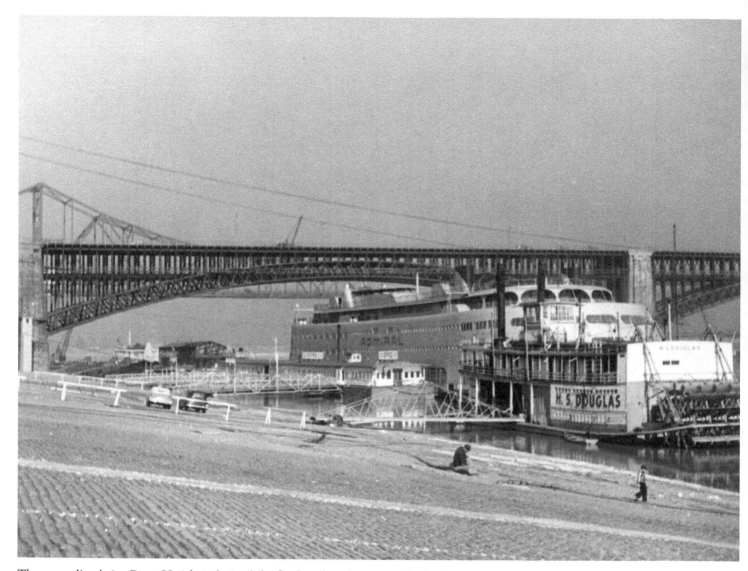

The streamlined, Art Deco SS *Admiral* stirred the fondest thoughts among St. Louisans. Beginning in 1940, St. Louisans filled its five decks for day trips along the Mississippi. This largest of the Streckfus line of riverboats boasted observation decks, dance floors, and arcades. Even the ladies' powder rooms were stylish, decorated in the tastes of stars like Sonja Henie, Greta Garbo, and Deanna Durbin.

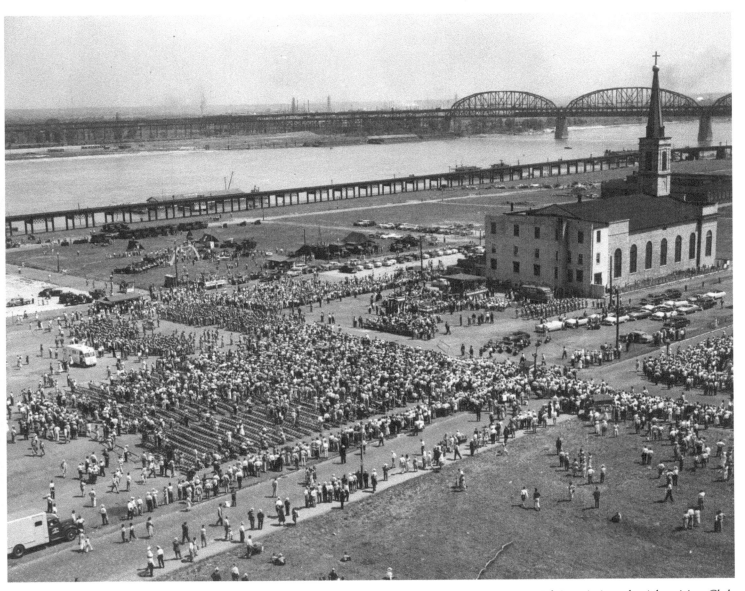

On June 23, 1959, the Jefferson National Expansion Memorial Association, the Advertising Club of St. Louis, and downtown St. Louis hosted a celebration—the ground-breaking ceremony for the Railroad Relocation Project. The relocation was the first step in the actual construction of the Gateway Arch.

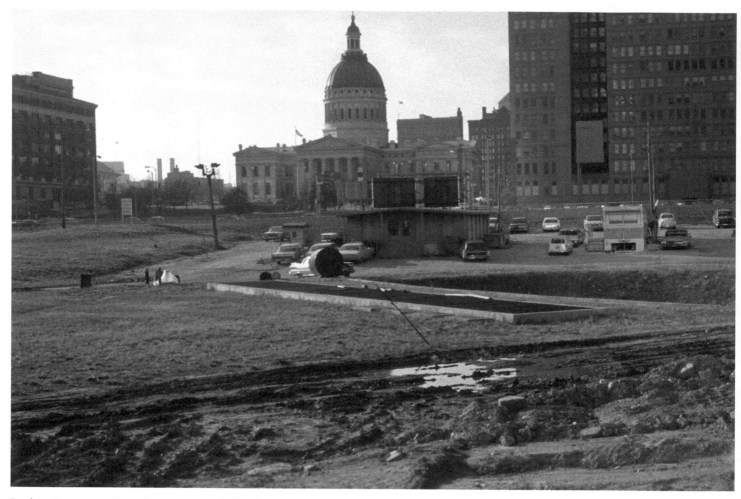

In this view, excavation is beginning. To build the foundation for the Gateway Arch, and the underground museum, 300,000 cubic feet of earth and rock were removed. The foundation extended to a depth of 60 feet, 30 feet of it into bedrock.

A Monumental Construction Project

(1960–1967)

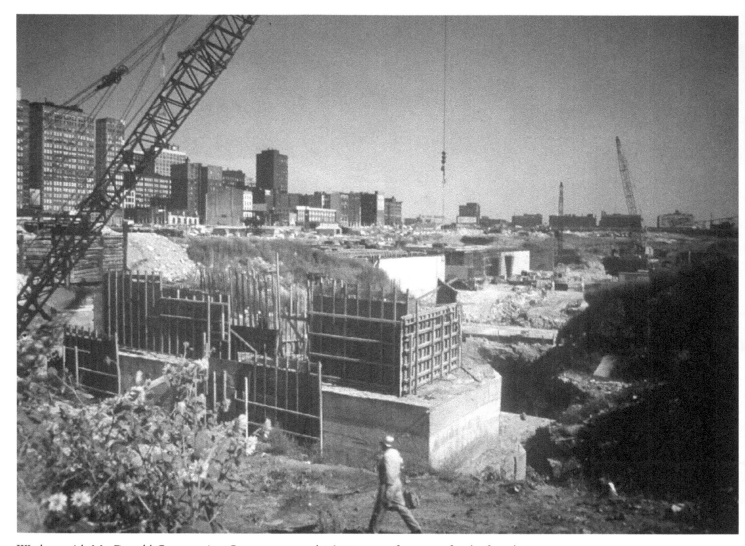

Workers with MacDonald Construction Company poured 26,000 tons of concrete for the foundation of the Gateway Arch. Meanwhile, steel workers at the Pittsburgh and Warren, Pennsylvania, plants of the Pittsburgh-Des Moines Steel Company fabricated the wedge-shaped sections of the Arch. The steel rods protruding from the foundation enabled the Arch to withstand mighty winds, swaying only 18 inches in a 150-mile-per-hour blast.

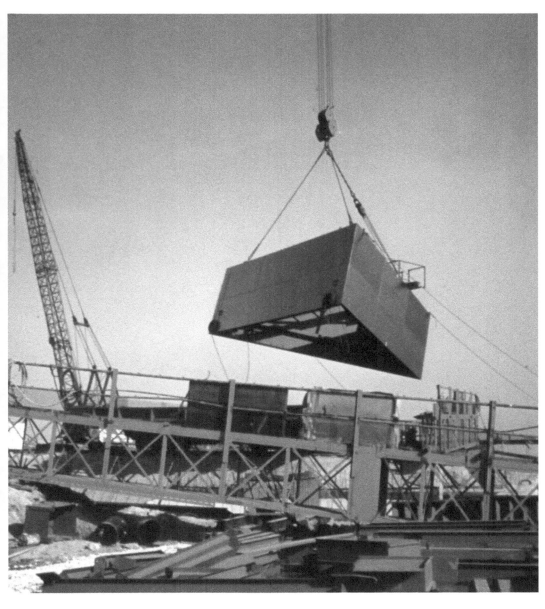

The stainless-steel sections of the Arch were shipped to St. Louis by rail. Craftsmen with Pittsburgh-Des Moines Steel set in place the first section of the Gateway Arch on February 12, 1963. The first six triangular sections, or lower 72 feet of the Arch, were lowered into place by conventional cranes.

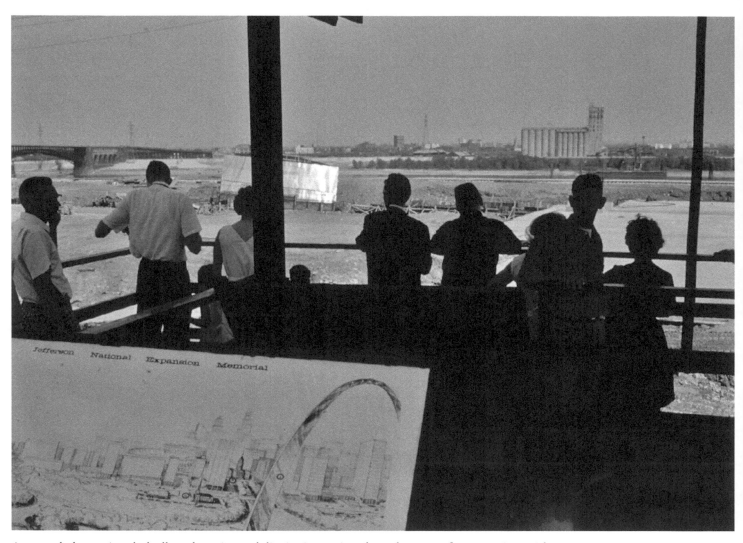

Jefferson National Expansion Memorial

A covered observation deck allowed tourists and dignitaries to view the early stages of construction, without interfering with the tangle of concrete trucks and construction vehicles supplying the huge project.

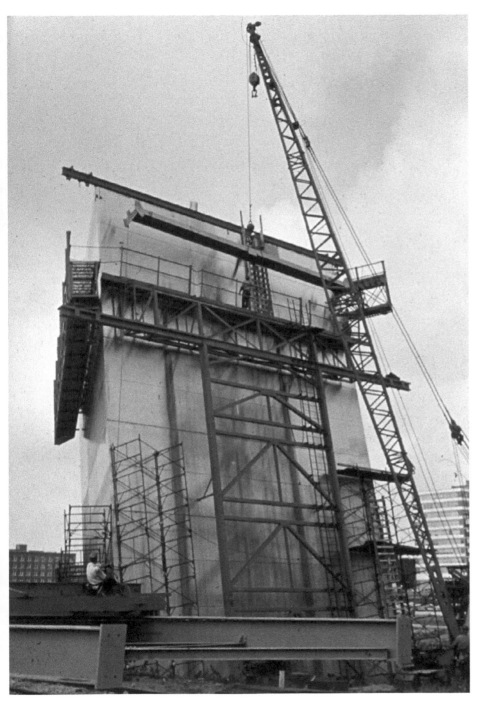

With only the bottom sections of the legs in place, surrounded by cranes and scaffolds, it was hard for St. Louisans to imagine how slender and graceful the Arch would eventually appear to be.

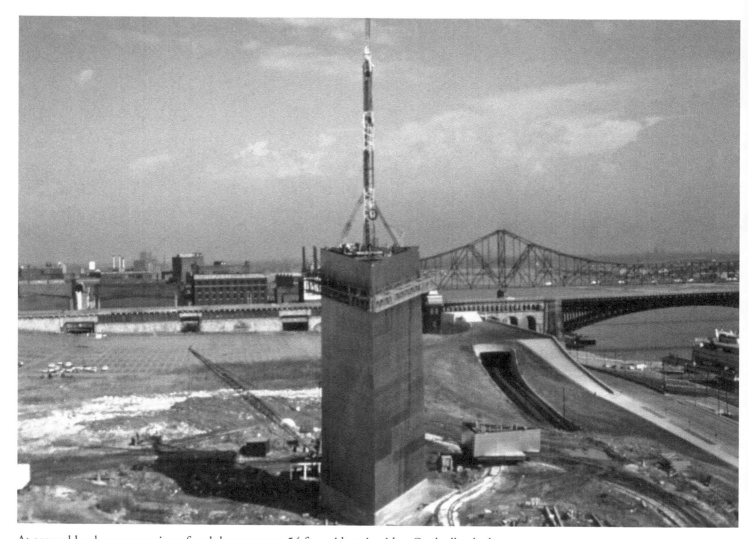

At ground level, a cross section of each leg measures 54 feet wide at its sides. Gradually, the legs grew more and more slender as they rose. At the top of the Arch, the legs measure only 17 feet wide at the sides. The thickness of the walls also diminished as the Arch grew, shrinking from 3 feet thick at ground level, to less than 8 inches thick when the legs reached over 400 feet into the air.

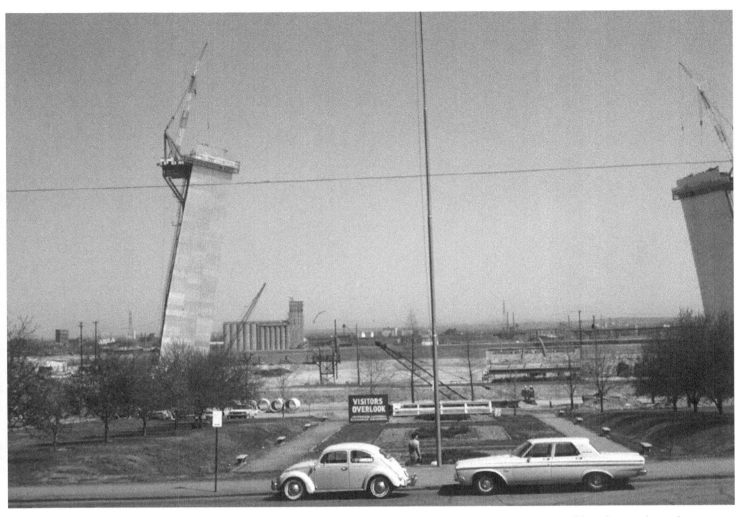

Once the legs of the Arch reached a height of 72 feet, construction could no longer depend on cranes operating from the ground. The engineers devised an alternative to traditional scaffolding. Tracks were constructed up the outside wall of each leg. Creeper derricks, each weighing one hundred tons, rested at the top of the tracks, moving upward as the Arch rose.

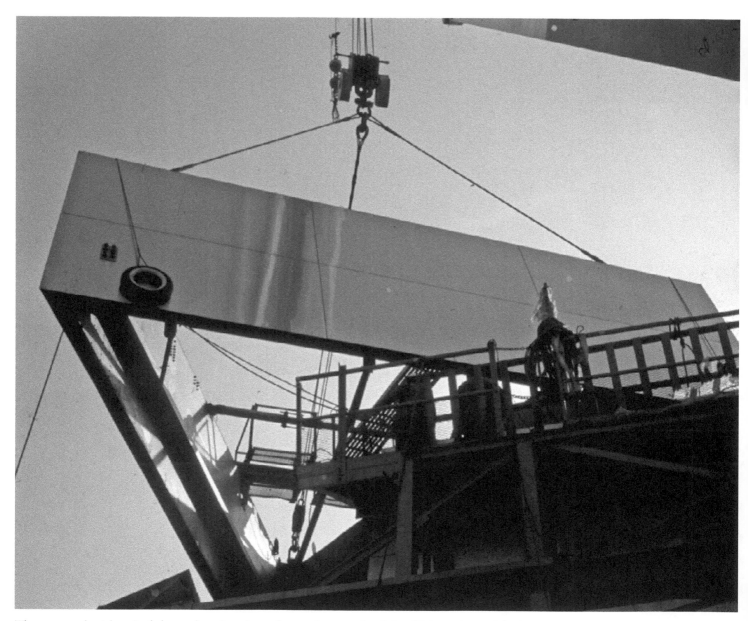

The creeper derricks raised the steel sections into place at the top of each leg. This section weighed around 50 tons. To ensure the stability of the 630-foot-tall Arch, each wall was built like a sandwich, with concrete poured between an outer skin and interior wall, up to the 300-foot level. Pre-stressed steel rods or tendons embedded in the concrete strengthened the remarkable structure.

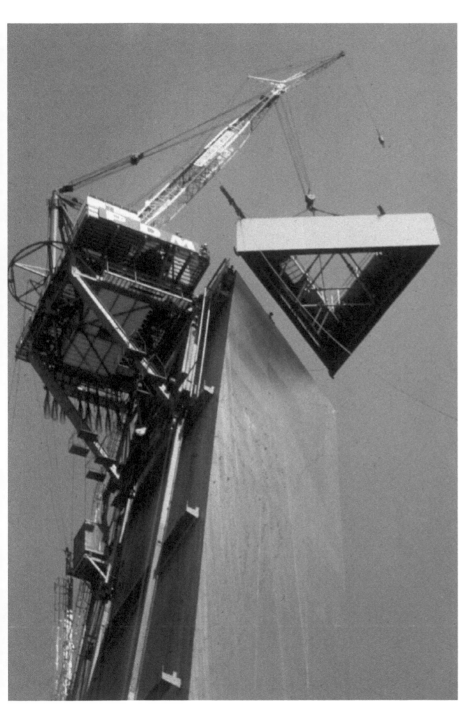

The derrick platforms measured 43 feet by 32 feet. A tool shed, a heated shed for workmen, sanitary facilities, and communications equipment sat atop each platform.

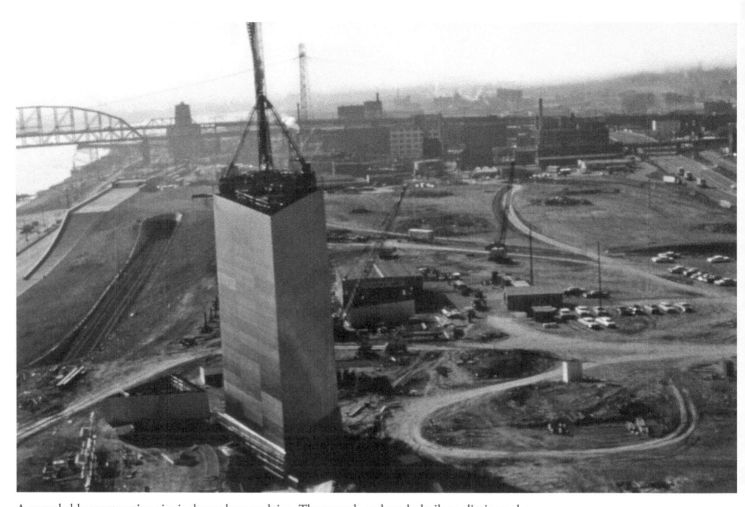

A remarkable construction site is shown here evolving. The tunnels and tracks built to eliminate the railroad trestle were tucked into the landscape taking shape at left. Sweeping dirt roads served as paths for construction trucks, all leading to the two, silvery, wedge-shaped legs.

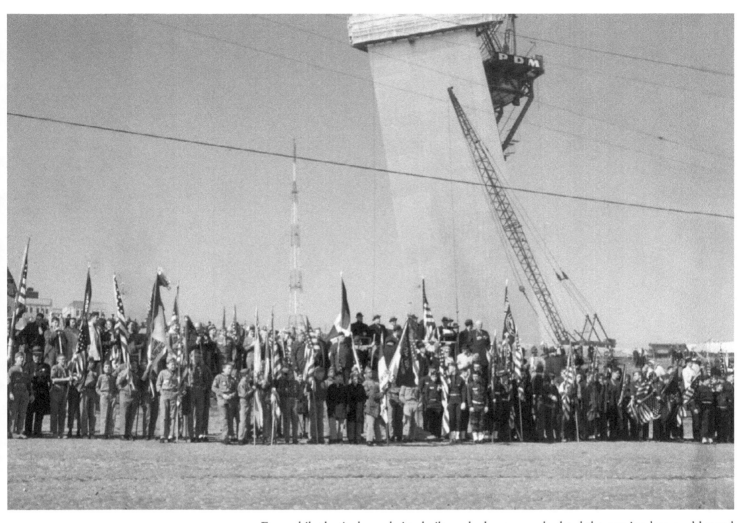

Even while the Arch was being built, and when many doubted the curving legs could stand individually long enough for them to meet at a height of 630 feet, and when many more doubted that the legs would meet at the top—even then people wanted their picture taken in front of the Arch. In this image, scores of Boy Scouts and dignitaries pose with flags at the construction site.

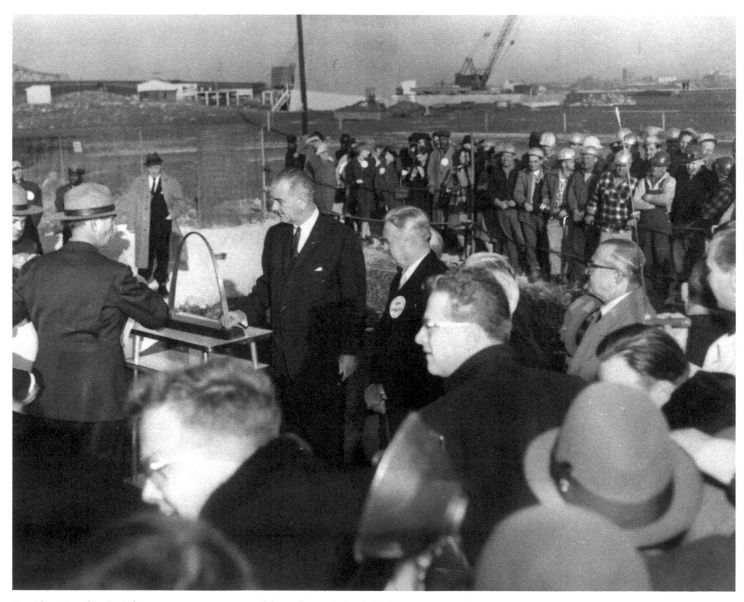

President Lyndon B. Johnson came to town to address the city's birthday banquet on February 14, 1964, the 200th anniversary of the founding of the city of St. Louis as a French fur-trading post. During his visit, Park Service personnel, Missouri senator Stuart Symington (to the right of the president), and construction workers welcomed the 36th president of the United States to a view of the construction in progress.

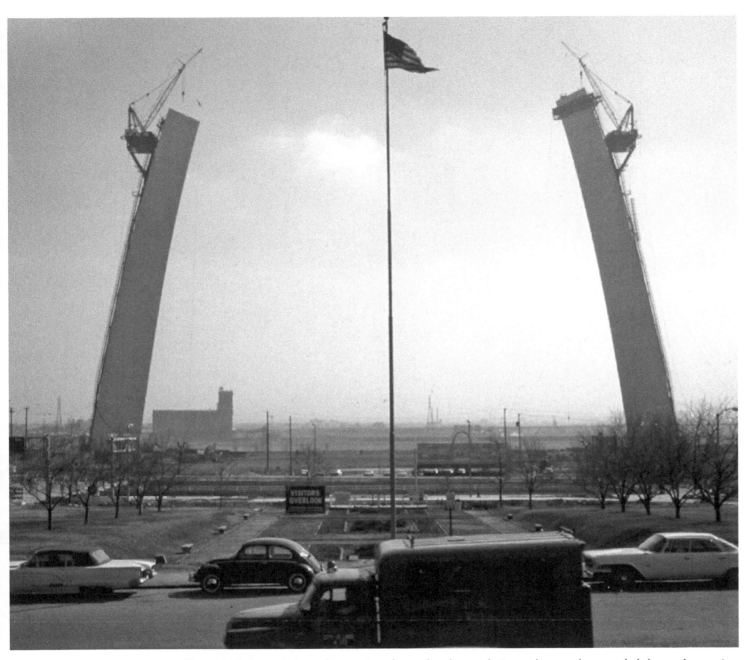

To reach their work site each morning, the steelworkers rode in an elevator that traveled the tracks curving up the outer walls of the legs of the Arch. Eventually, 11 minutes were needed to reach the top by elevator.

As the legs of the Arch continued to grow taller, and each curved more toward the other, their strength diminished. At the 530-foot level, the legs alone would no longer be able to carry the weight of construction.

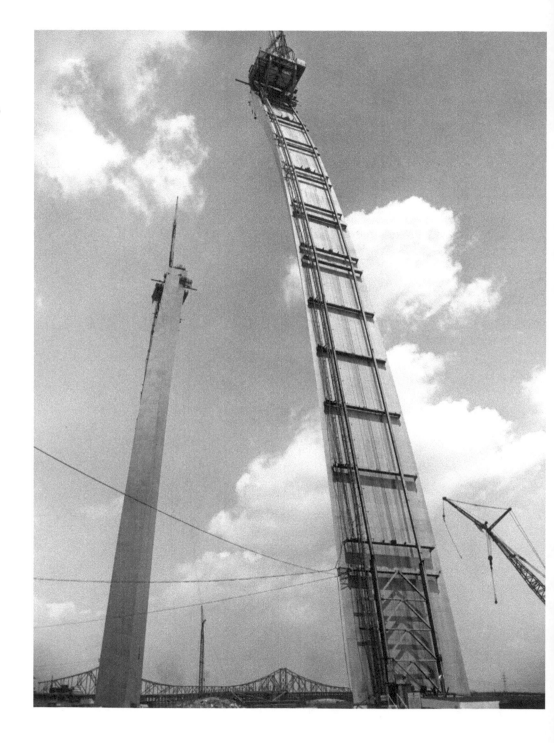

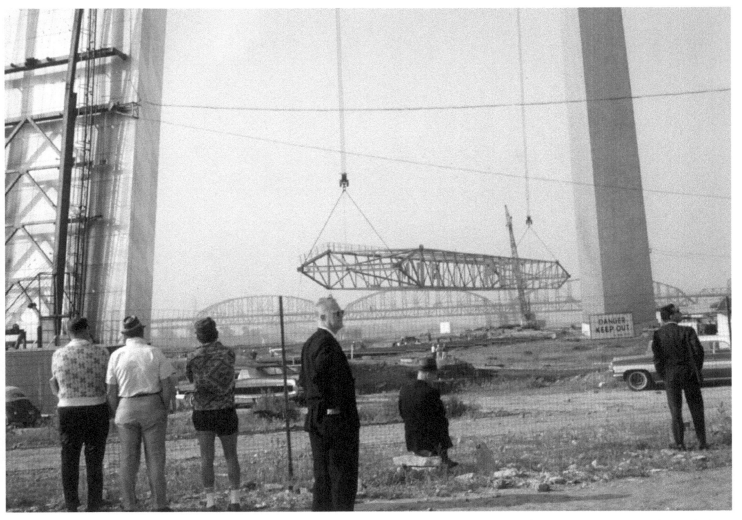

Using the derricks, workmen lifted a 255-foot-long strut to the top of the construction site to brace the legs.

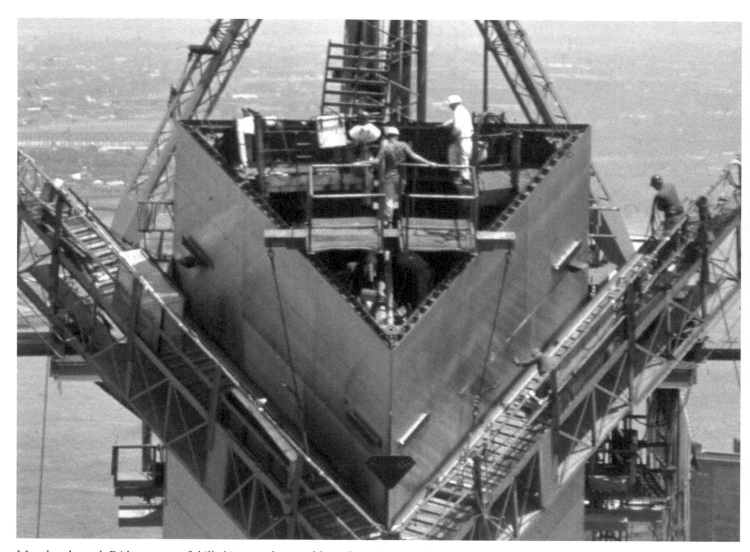

Monday through Friday, scores of skilled ironworkers, welders, electricians, machine operators, concrete men, pipefitters, and sheet metal specialists rode their unique elevator to their extraordinary workplace in the sky over the historic riverfront. At this elevation, the width of each side of the stainless-steel legs has narrowed from 54 feet at the base to just over 20 feet.

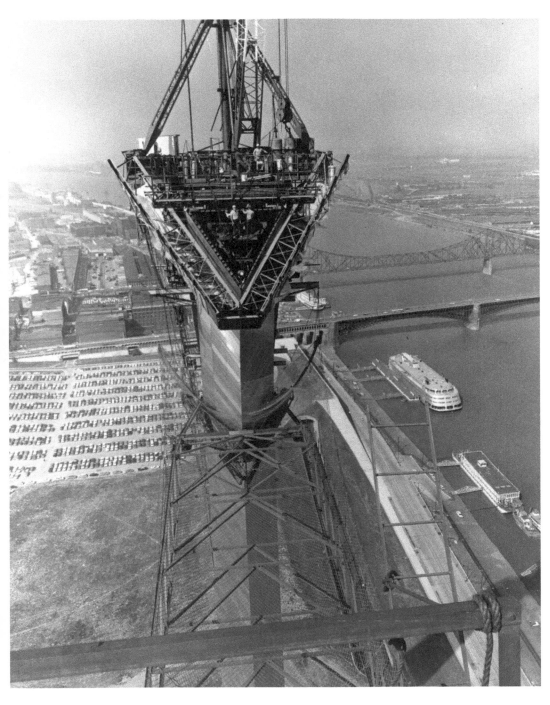

The north riverfront, with the *Goldenrod* showboat, the *Admiral,* the Eads Bridge, the Veterans' Bridge (renamed Dr. Martin Luther King, Jr., Bridge in 1968), and the workmen atop the north leg of the Arch appear in this view from the platform atop the south leg.

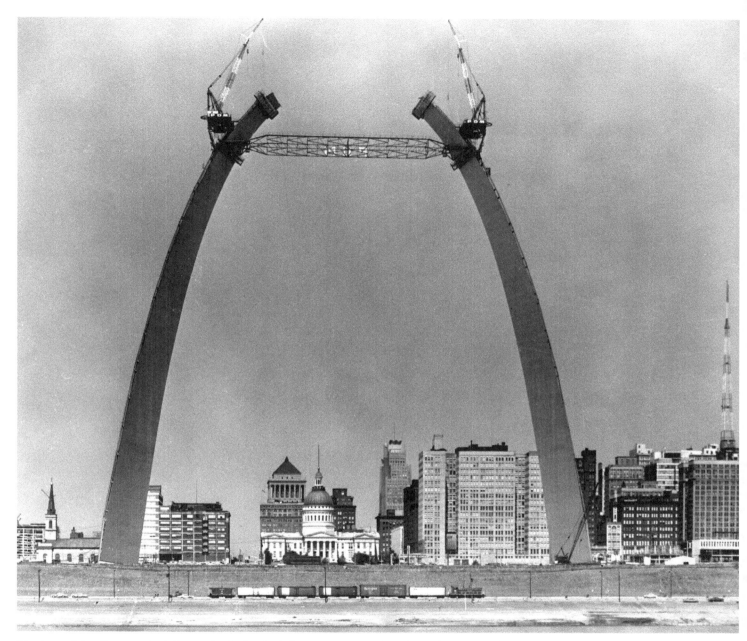

The legs of the Gateway Arch frame the St. Louis skyline as it appeared in the mid-1960s, before the late-twentieth-century building boom would again expand the skyline. Although the elevated railroad was tucked into the landscape of the Arch, tracks still carried trains along Wharf Street.

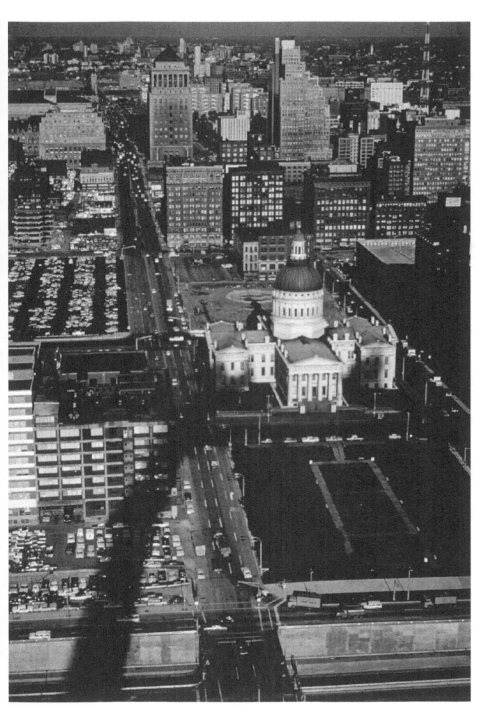

The still unfinished Arch casts its early morning shadow across downtown St. Louis. This view revealed a troubling trend. Surface parking lots had replaced many buildings.

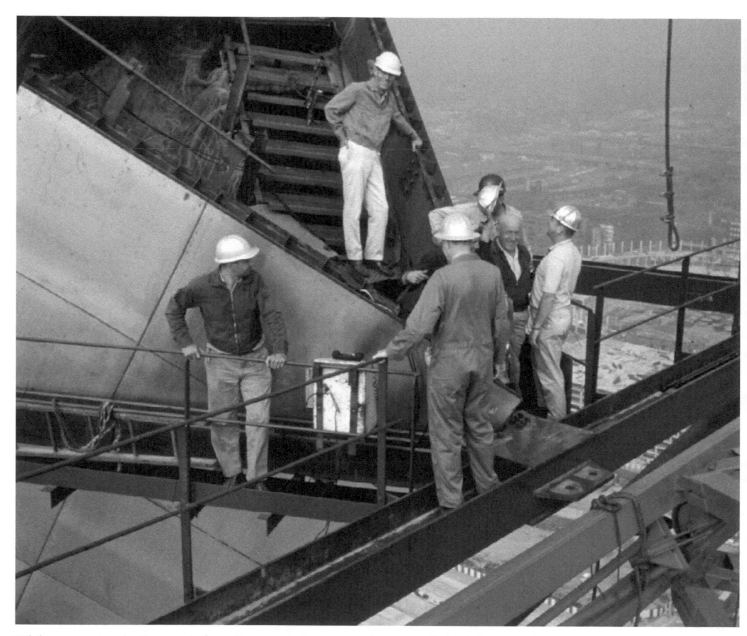

While constructing the Gateway Arch, craftsmen were also constructing a one-of-a-kind elevator and a staircase with 1,076 steps from the base to the top. The elevator capsules would enable visitors to reach a planned observation deck at the summit.

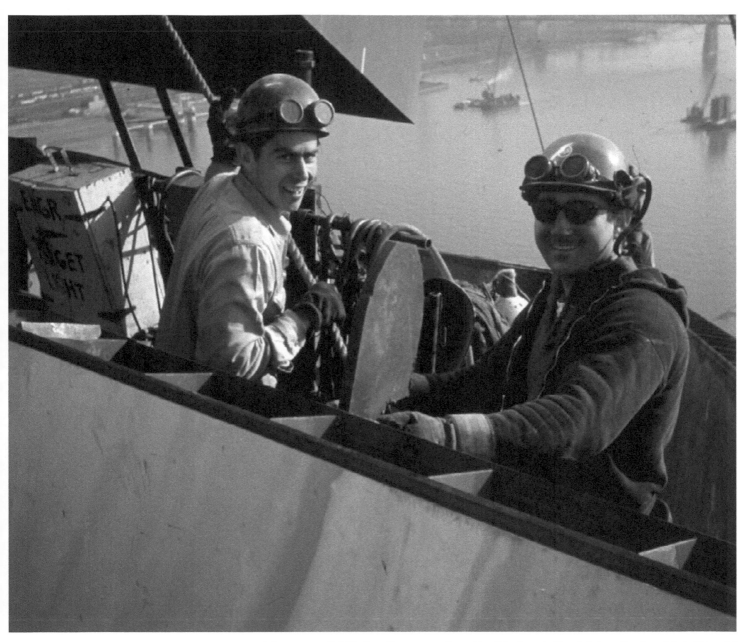

The scores of skilled craftsmen employed by Pittsburgh-Des Moines Steel and MacDonald Construction Company of St. Louis, the prime contractor, were keeping the job of building the Gateway Arch both under budget and on schedule.

Smooth stainless steel, a quarter-inch thick, sheathed the Arch. As the monument reached completion, St. Louisans were surprised to see that sometimes at dusk the smooth steel reflected light in wrinkled patterns. Some mockingly called it the "Gateway Prune."

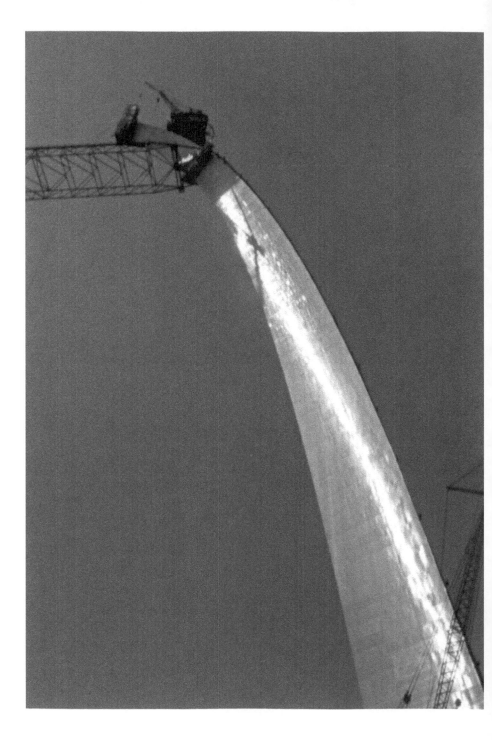

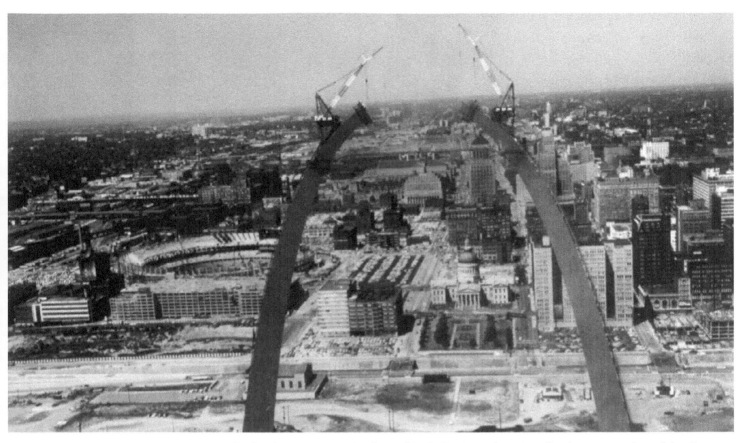

Steel and concrete were in demand in St. Louis, and not just for the construction of the Gateway Arch. Behind the south leg of the Arch, the coliseum-style Busch Stadium is visible in early stages of construction. From 1966 to 2005, the stadium would be the downtown home for the St. Louis Cardinals baseball team.

As the curvature of the two legs began to close, the view of the St. Louis skyline became more interesting, but welders advanced to ever more precarious circumstances.

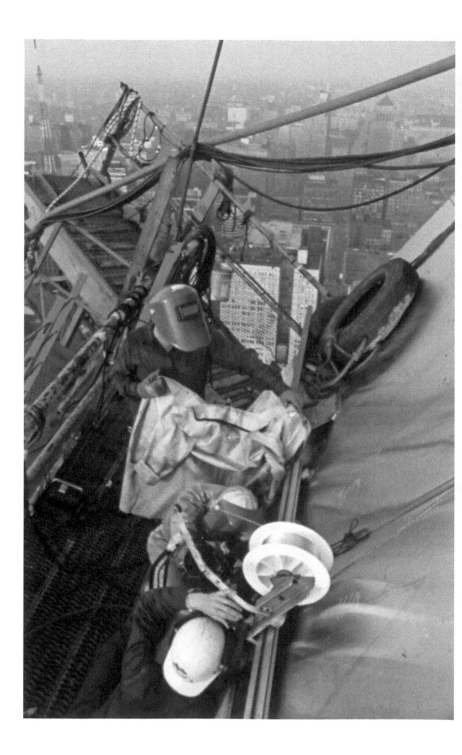

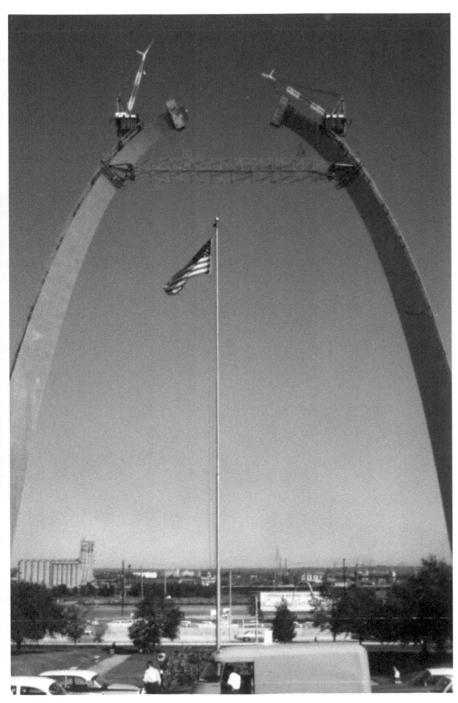

During the summer of 1965, excitement was growing across the city of St. Louis as the legs curved ever closer to each other.

At dizzying heights, whipped by wind, and occasionally even balanced on a crate, the hardhats welded the huge triangles together with daring and skill. The building in the distance, topped by a stepped pyramid, is the Civil Courts Building, which opened in 1930. The Art Deco skyscraper provided more rooms and conveniences for the court system, which had been housed in the Old Courthouse since the 1840s.

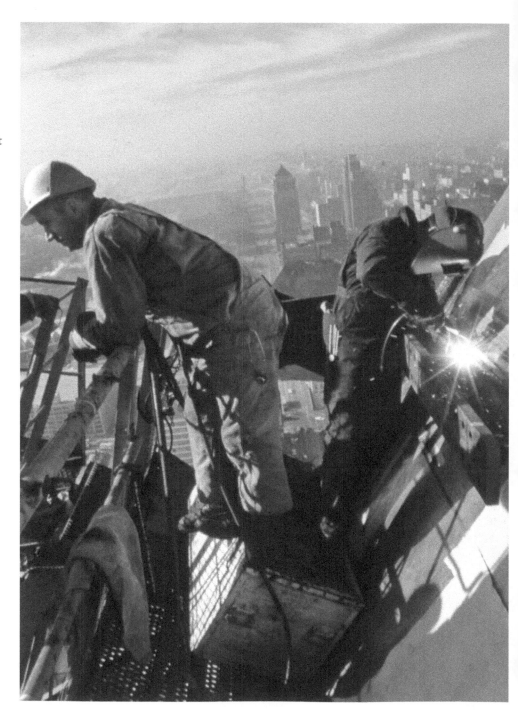

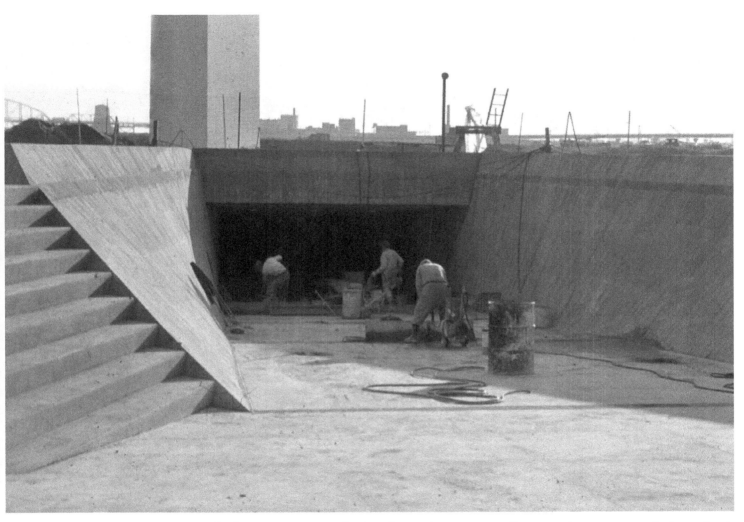

Craftsmen were constructing broad, sweeping concrete walkways to the entrances at the base of each leg. The distance at their base between one leg and the other equaled the height of the Arch, 630 feet.

This craftsman appears to be next to a wall of stainless steel. Saarinen had chosen stainless steel to sheath the Arch because it had both a modern quality and great strength. When the Arch was completed, the stainless steel used for the exterior skin would weigh 886 tons.

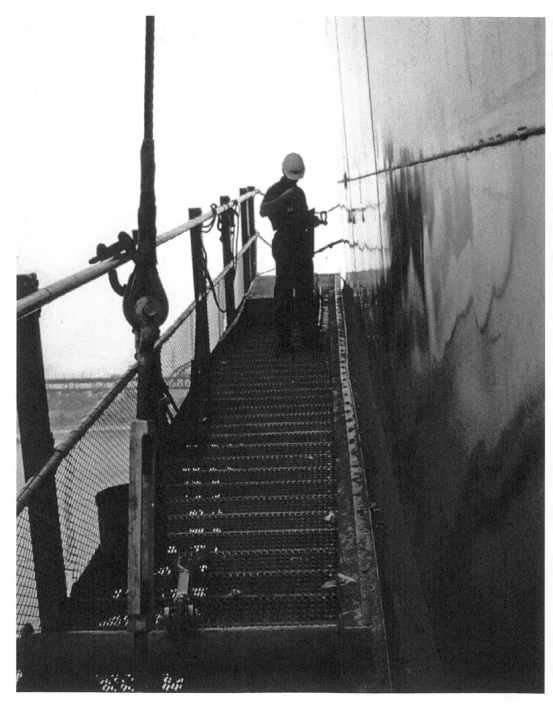

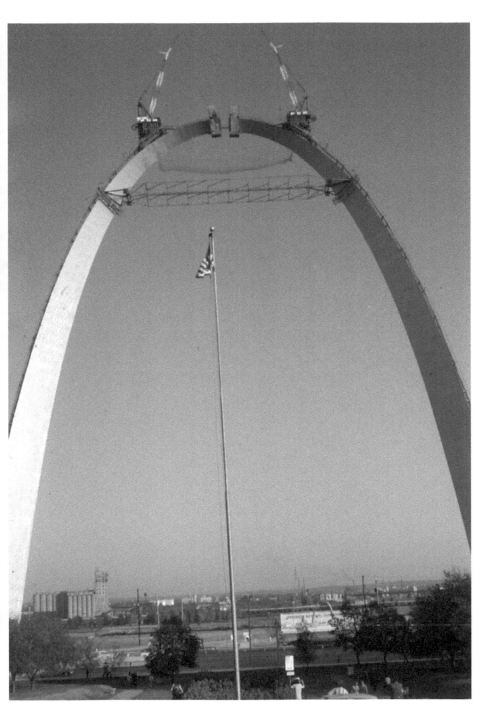

By October 1965, 143 wedge-shaped sections of stainless steel were in place, each secured and welded, and interior systems were under construction. Onlookers in the foreground peer upward, focusing on the gap between the legs of the Arch as construction nears completion.

On the morning of October 28, 1965, St. Louis came to a standstill. Regular classes were canceled in St. Louis public grade schools, as the children proceeded to the schools' TV rooms to watch the televised installation of the keystone, completing the Gateway Arch. Children lucky enough to attend schools near downtown walked up the stairs to third-floor classrooms, where windows offered a view of the momentous event.

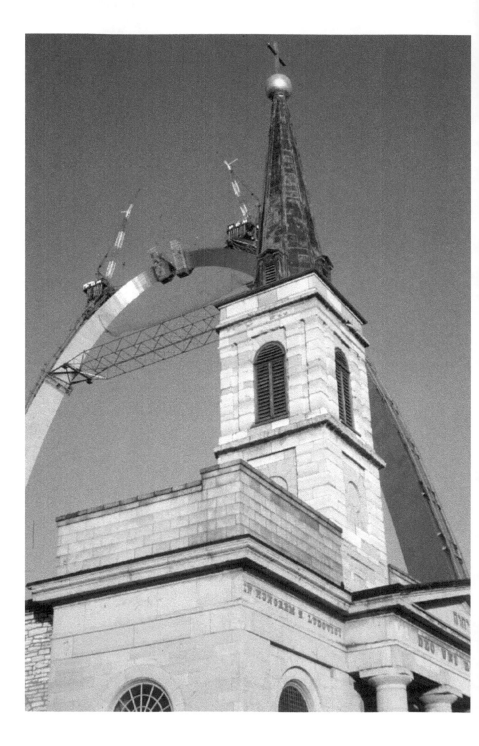

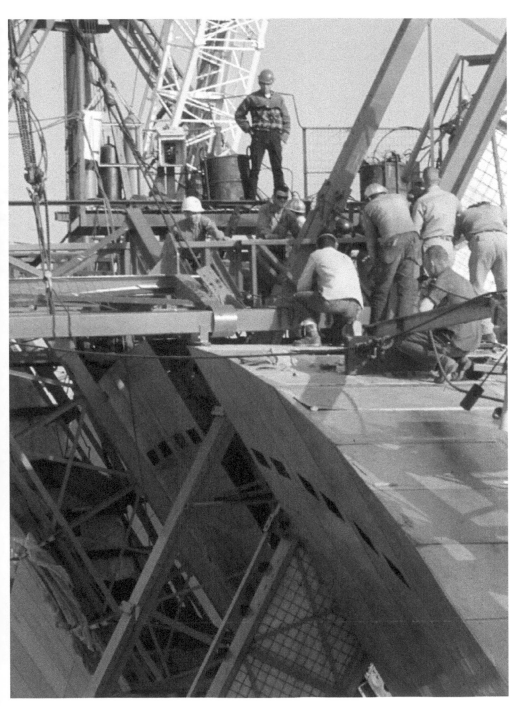

At the top of the Arch, craftsmen observe progress with the same eye for exactitude that they had used during each step of construction over the preceding three years. In this view, it appears that steel scaffolding is being removed to make way for the keystone section.

Despite the temperature in the 40s, some experts feared the bright sunlight might warm the south leg of the Arch, causing a slight expansion. Sunlight heating the outside of the south leg could ruin the alignment of both legs, causing the final section not to link properly. As the derricks lifted the keystone up 630 feet, St. Louis firemen came to the rescue. They lined up their fire trucks at the foot of the south leg and sprayed volumes of cooling water at the base of the leg, to counteract the heat of the sunlight.

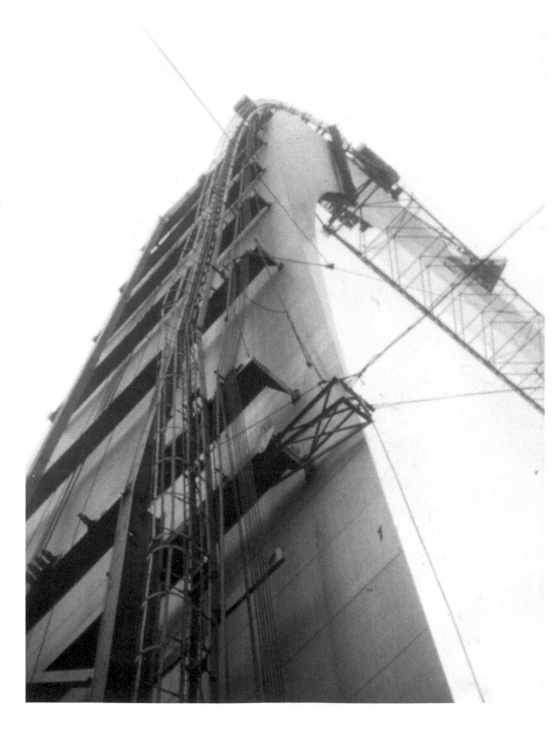

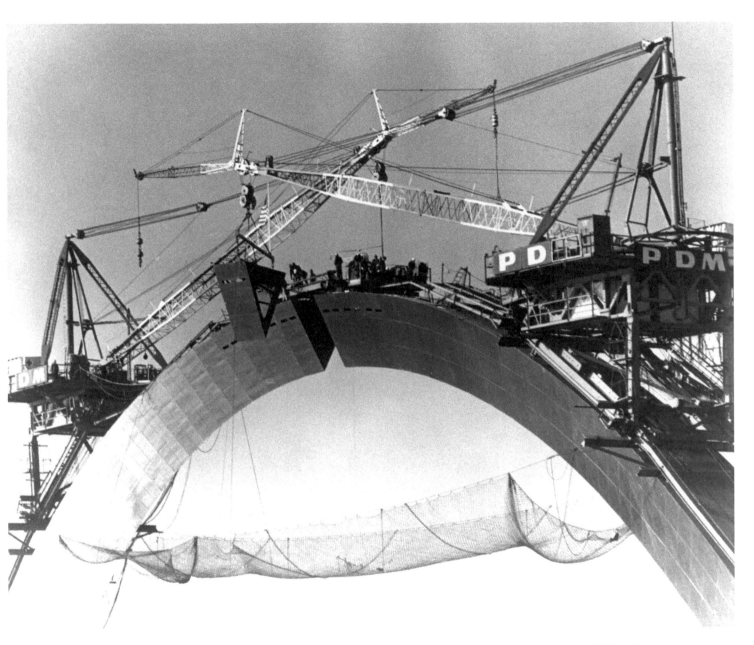

Work had halted in the offices of downtown St. Louis. Secretaries and CEOs alike stood poised at the windows on the east sides of skyscrapers and high-rises throughout the downtown area. With binoculars, they watched the keystone creep ever so slowly toward the gap at the top of the Arch.

With the jacks pushing the legs of the Arch apart, the steelworkers, welders, and engineers began slipping the final section into place. One woman spectator said, "I hope somebody up there has a shoehorn."

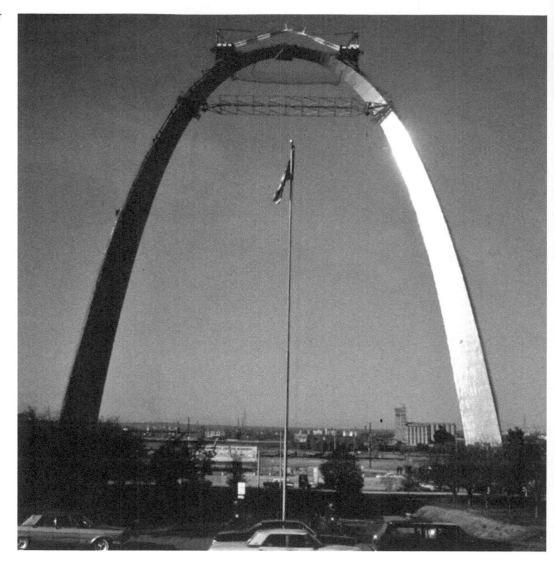

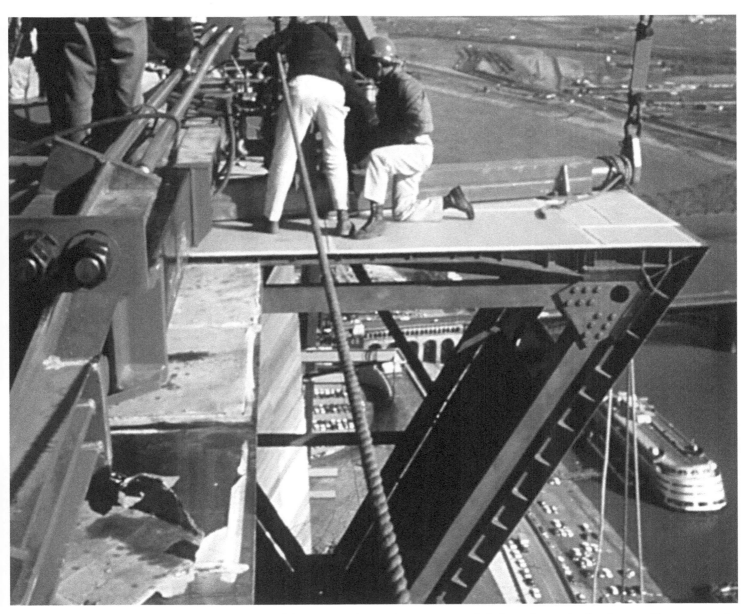

Some of the construction workers were actually balanced atop the floating, steel keystone as the derrick operators moved it into the gap. When the keystone fit between the legs, the riverboats below blew their whistles in celebration. Concentrating on his work, one of the workmen seemed almost annoyed by the noise and asked what it was all about. Another hardhat unemotionally explained that the people below were celebrating.

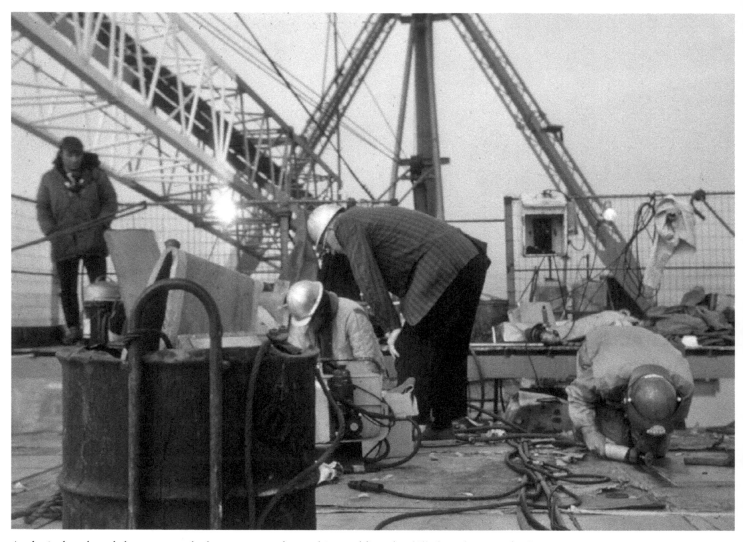

As the jacks released the pressure, the keystone was clamped in, enabling the skilled workmen to begin sealing the 144th section into place. The amazing feat had been achieved by 11:05 A.M.

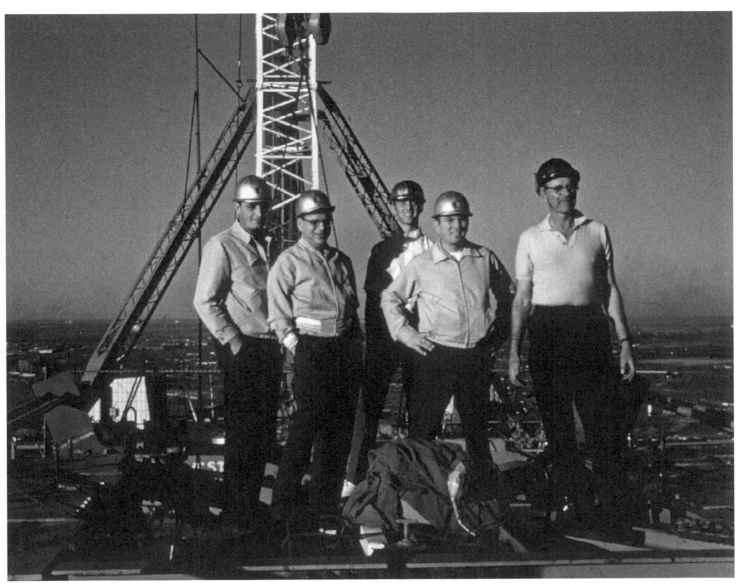

Many cheered. Many schoolchildren, however, were disappointed. They had hoped that completing the Arch would take at least until noon, so that they would be excused from all their morning classes. The engineers and construction workers were bursting with pride. And Gene MacDonald, president of the St. Louis firm holding the general contract for the Gateway Arch said, "This is the day I throw the aspirin bottle away."

Tracks, cranes, and elevators cluttered and
hid the silvery beauty and slender shape of
the Arch. The arduous task of removing
the mechanics of construction was just
beginning.

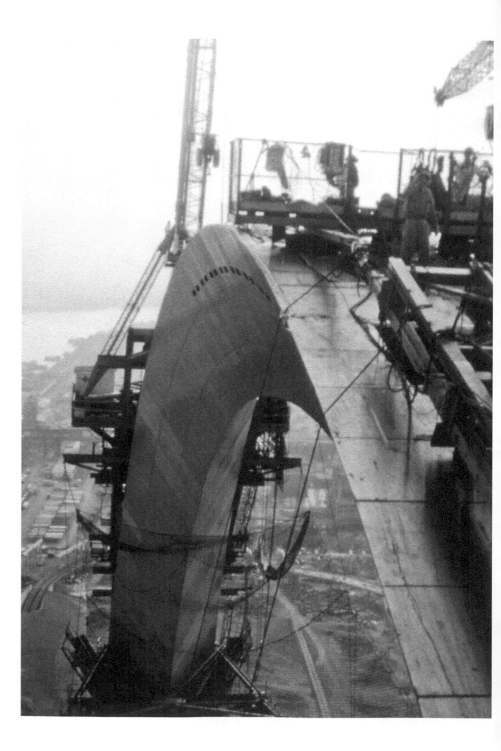

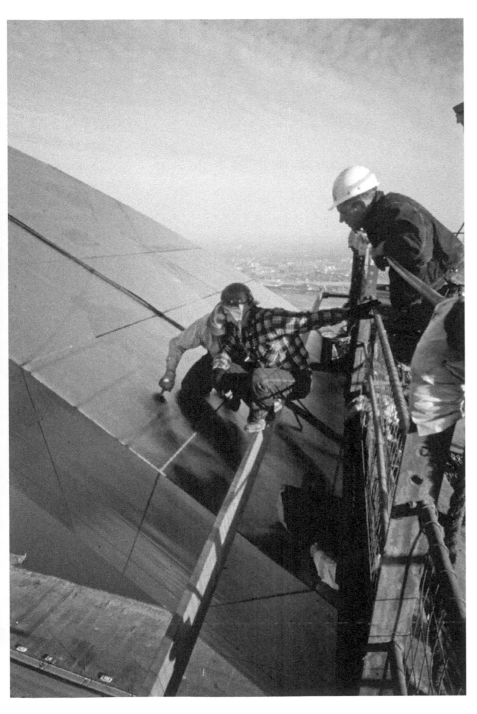

There was work to do as the tracks were removed. After dismantling a section of the tracks, the craftsmen used stainless-steel plugs to fill in all the holes that had been created to support the derrick. This procedure had to be repeated for each section of track.

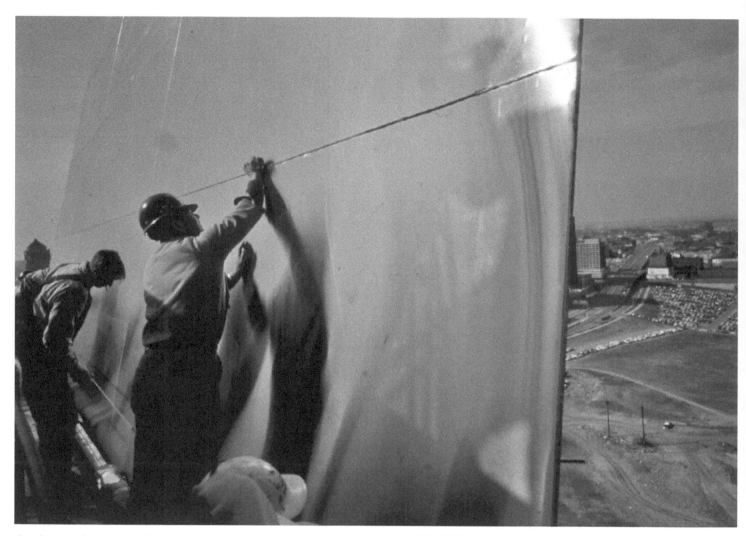

On the way down, imperfections and scars were corrected, smoothed, and polished. The workmen appeared to give the same care to the finish of the 630-foot stainless-steel Arch that they would to a prized sports car. This procedure took nearly a year.

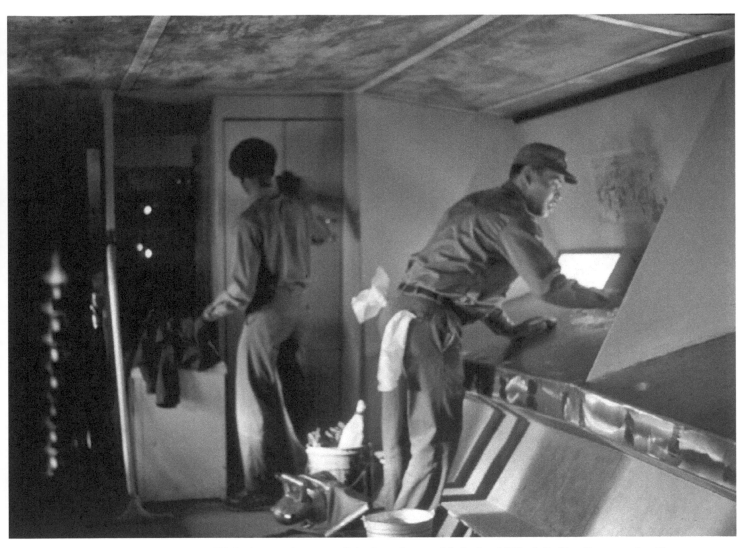

While the exterior was polished, workmen with St. Louis' Hoel-Steffen Construction Company were finishing the interior of the observation deck.

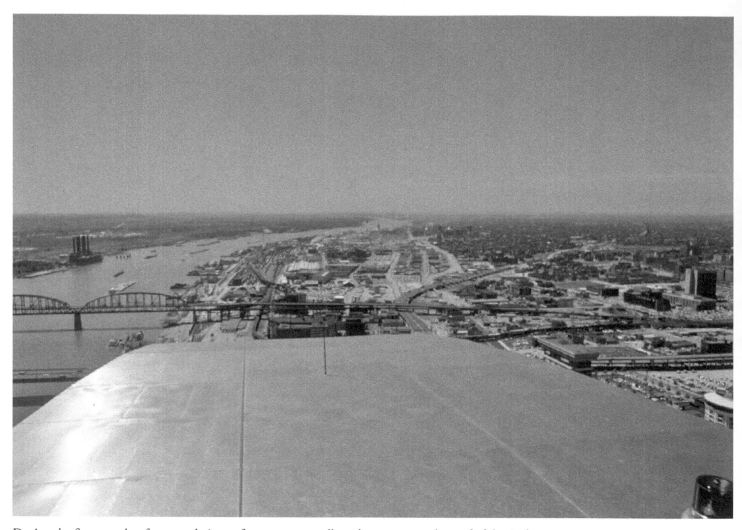

During the first months after completion, a few guests were allowed to step onto the roof of the Arch for an astonishing view. This image faces south, where at left the Mississippi curls into the distance. Huge barges, which appear to be the size of dominoes seen from the top of the Arch, are making their way through the channel.

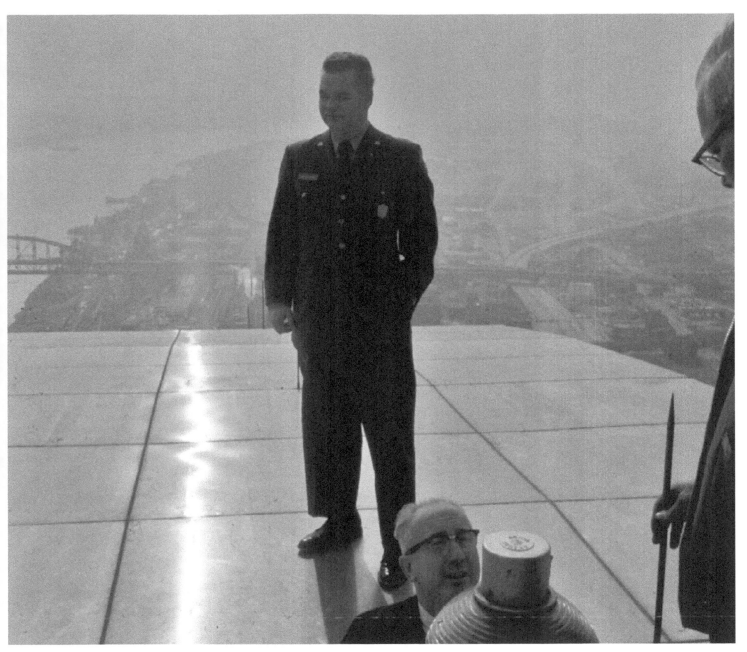

A rightfully proud Leroy Brown, Superintendent of Jefferson National Expansion Memorial from 1965 to 1968 and again from 1974 to 1975, views the city from the top of the Gateway Arch.

In May 1967, *St. Louis Post-Dispatch* photographer Art Witman (center) and others are joyous at the opportunity to photograph the city from the top of the Arch.

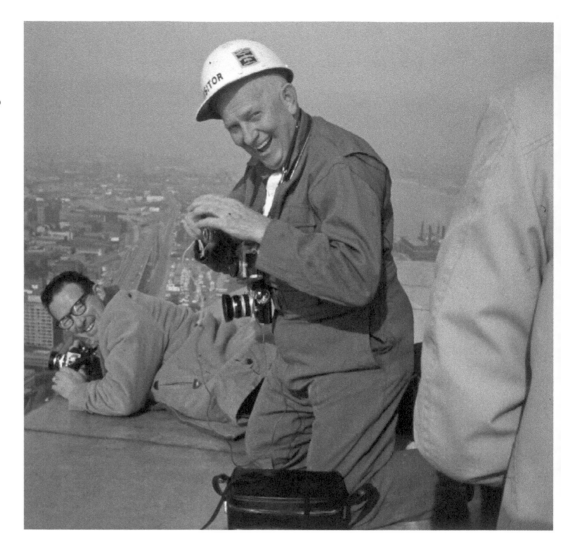

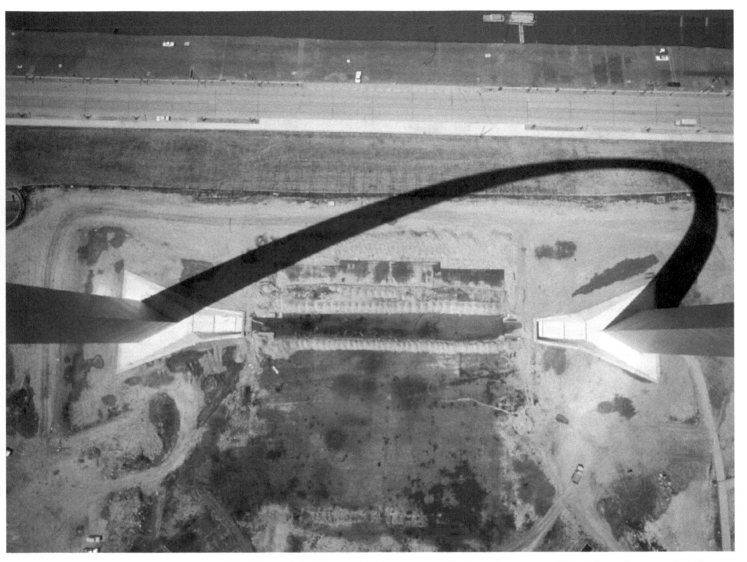

The shape of the Gateway Arch can create illusions. A camera with a fish-eye lens caught this one, which makes it appear that the legs of the Arch rise vertically and do not meet. The early afternoon sun, however, defines the true shape of the Arch, which casts a powerful shadow across the muddy construction site below.

Seventy-five feet taller than the Washington Monument and 175 feet taller than the Statue of Liberty, the completed Gateway Arch surpassed all other American monuments in height and rivaled the great monuments of the world. This illustration suggests the comparative heights of these well-known monuments and the Eiffel Tower.

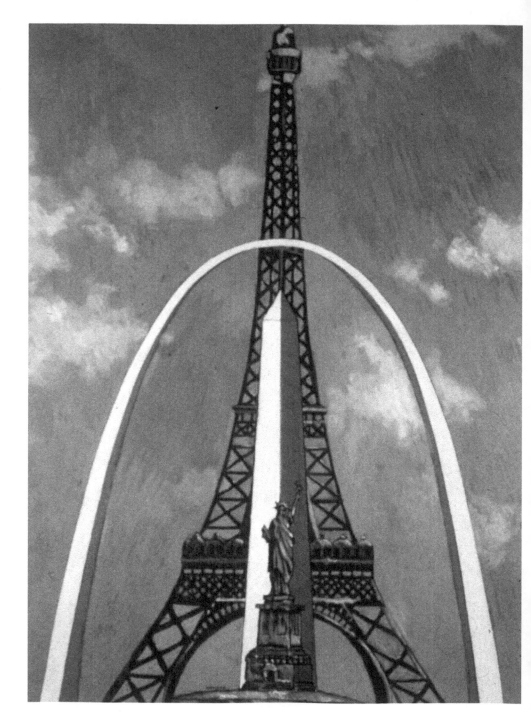

Symbol of Optimism and Unity

(1968–1970s)

On May 25, 1968, dignitaries from across the state and the nation gathered to dedicate the Arch. United States vice-president and presidential candidate Hubert H. Humphrey (at far left) poses with (left to right) Secretary of the Interior Stewart L. Udall, Missouri governor Warren E. Hearnes, and St. Louis mayor Alfonso J. Cervantes at the foot of the Arch. Upon seeing the Gateway Arch, the vice-president declared, "Fantastic. Incredible. Wow. Look at that."

George Hartzog (center), Director of the National Park Service and former superintendent of Jefferson National Expansion Memorial, speaks with Superintendent Leroy Brown, sporting a raincoat. A steady rain drowned out five band concerts scheduled for the dedication. Brown was forced to move the dedication ceremony to the facility underground, where only a few hundred dignitaries and spectators could be accommodated.

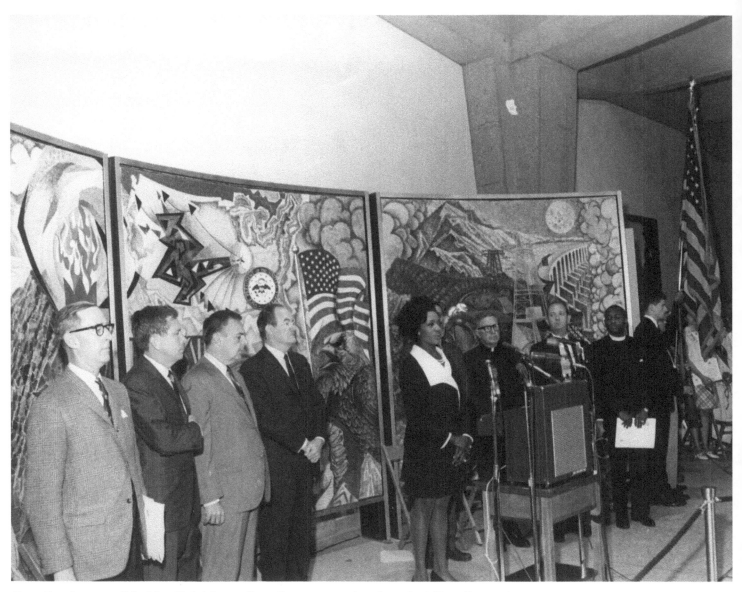

Grace Bumbry, star of the New York Metropolitan Opera, approaches the makeshift podium and stage to perform the National Anthem at the dedication. A St. Louis native, Bumbry's talent had been discovered and nurtured by the music program in the St. Louis public schools.

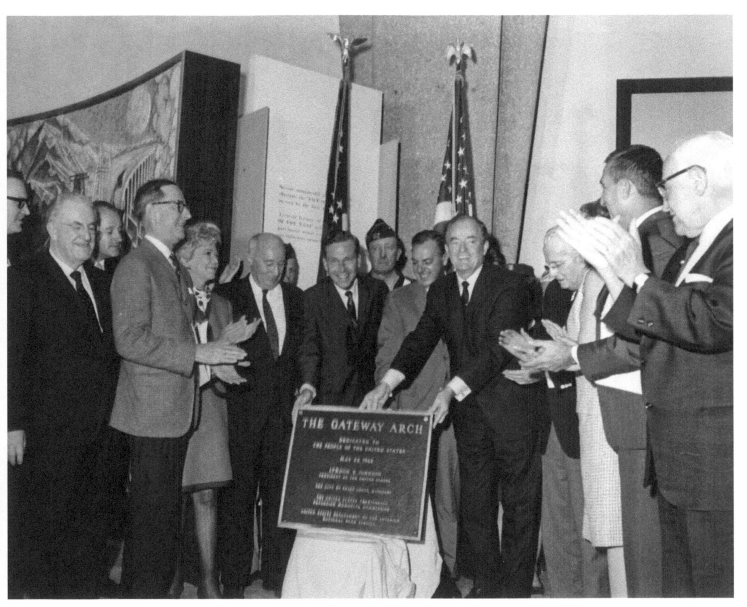

Humphrey described the Arch as "more than a symbol. A living memorial . . . for what it evokes in those who stand before it." Standing with Governor Warren Hearnes, the vice-president holds the plaque dedicating the Gateway Arch. Humphrey, who would become the Democratic candidate for president of the United States after a contentious convention in Chicago, would lose the November election to Richard M. Nixon.

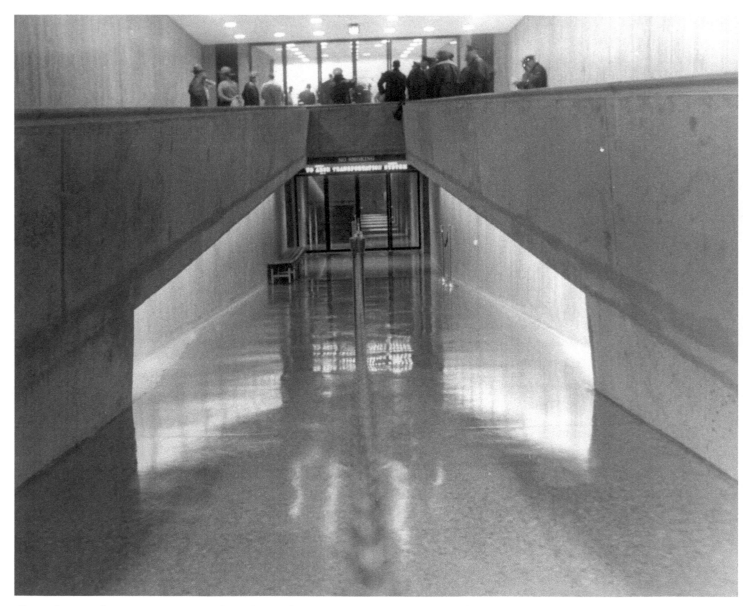

About the time the ceremonies were ending, the steady rain turned into torrential cloudburst. The rains overflowed the drains, then ran down the ramps into the museum under the Arch and to the elevator entrances. The vice-president and his entourage waited in an alcove for a break in the downpour. Then Humphrey said, "Let's make a run for it," and he plunged forward into the stream, followed by Secret Service agents and reporters.

National Parks personnel and St. Louis police decked out in rain gear are ready to assist the dignitaries. Only half an hour before the scheduled dedication, they had still hoped to hold the ceremonies as planned, outdoors.

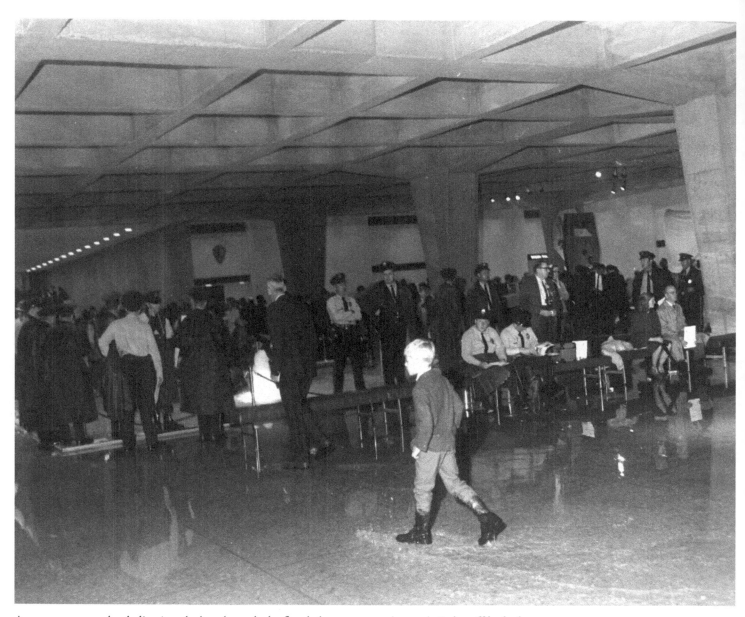

A young guest at the dedication sloshes through the flooded museum undaunted. Park staff had a huge mopping job ahead of them. The effects of the storm, which was more severe than any downpour many St. Louisans could remember, were aggravated by the fact that the Memorial's grounds had not yet been landscaped, leaving them unable to drain away the heavy rains.

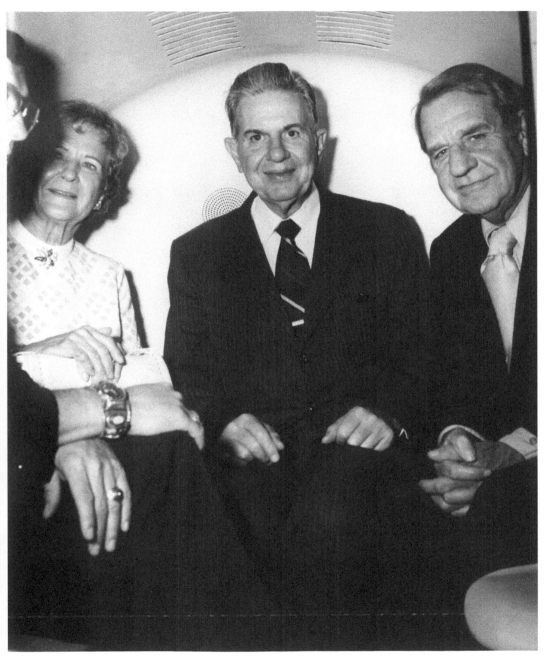

Superintendent of Jefferson National Expansion Memorial Ivan Parker, Missouri congresswoman Leonor Sullivan, city of St. Louis mayor (from 1973 to 1977) John H. Poelker, and Oklahoma congressman John Camp shared a ride in an elevator capsule to the top of the Arch. The one-of-a-kind elevator uses some of the principles of a Ferris wheel to ascend and descend the 630-foot-tall structure.

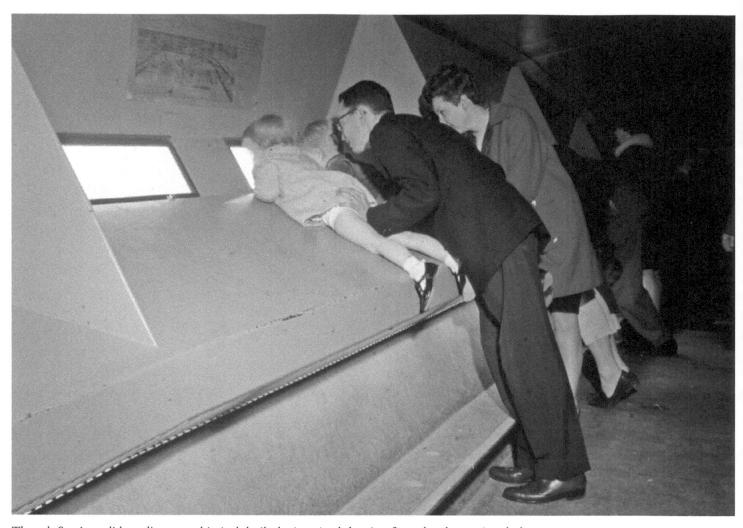

Though Saarinen did not live to see his Arch built, he imagined the view from the observation deck, and the national memory it would evoke. "Through the windows you see a beautiful sight. The whole city is glittering and glistening below. You see the Great Plains beyond the city, and you can see in your mind the great droves of people who landed here and passed under your feet on their way to open up the west."

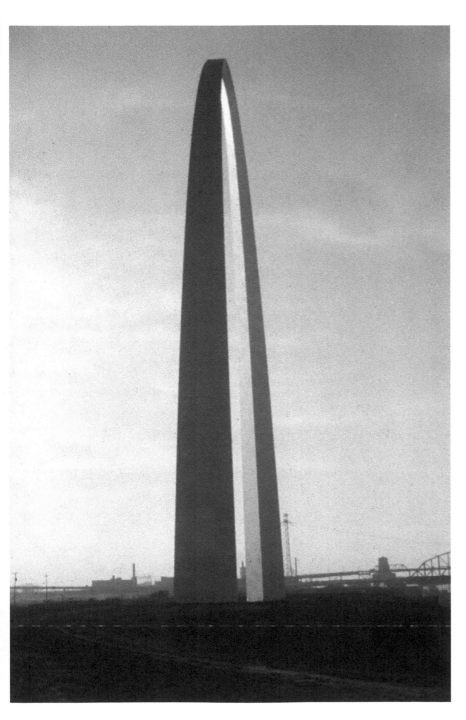

St. Louisans had joked that they were building a gargantuan croquet wicket on the St. Louis riverfront. But once the Gateway Arch was completed, with the derricks and tracks removed, and the whole structure polished to sparkling, St. Louisans and tourists alike were spellbound.

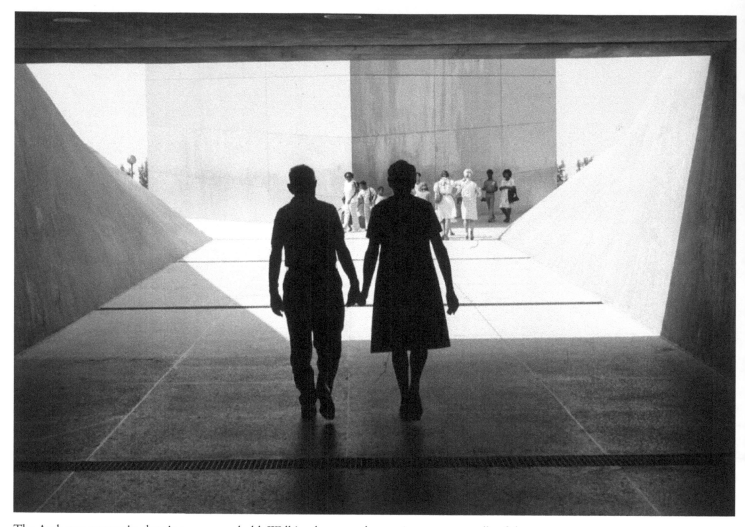

The Arch was magnetic, drawing young and old. Walking between the curving concrete walls of the entrances to the underground museum and elevators was a space-age experience.

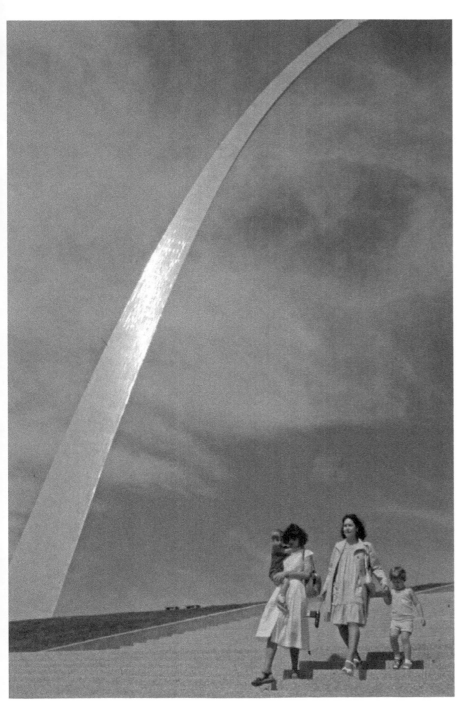

Unlike the Eiffel Tower, with its engineering exposed, the structure and engineering of the Arch was concealed, hidden behind its walls. Only the sleek surface of the Arch was visible. Its smooth, clean lines seemed to announce the space age, with all the benefits that space-age technology and science could offer Americans. When the Arch was dedicated, Stanley Kubrick's Oscar-winning film *2001: A Space Odyssey* was transfixing Americans at the box office, and Neil Armstrong, Buzz Aldrin, and Michael Collins were barely more than a year from leaving the first human artifacts on the moon.

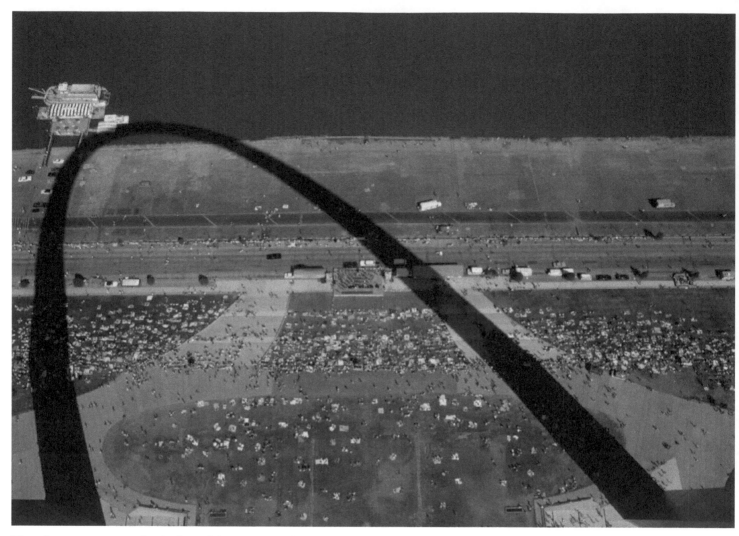

The afternoon sun casts the shadow of the Arch over the crowds gathered on the staircase and lawns to hear a concert performed on Wharf Street.

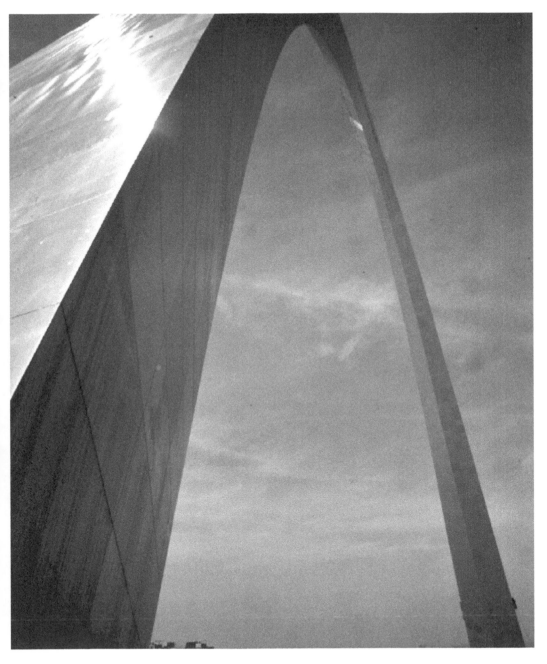

The Gateway Arch met the standard envisioned by civic leader Luther Ely Smith in 1944, of a memorial "transcending in spiritual and aesthetic values." Visitors to the recently completed monument felt as though they were visiting a new wonder of the world.

Sloping, smooth, concrete walkways leading along a stepped concrete wall, with the modern, concrete buildings in the background imparted to some perspectives of the Arch a similarity to sets for science fiction films. One young man in this image has stopped to touch the stainless-steel walls of the Arch, reminiscent of a scene from Kubrick's *2001*.

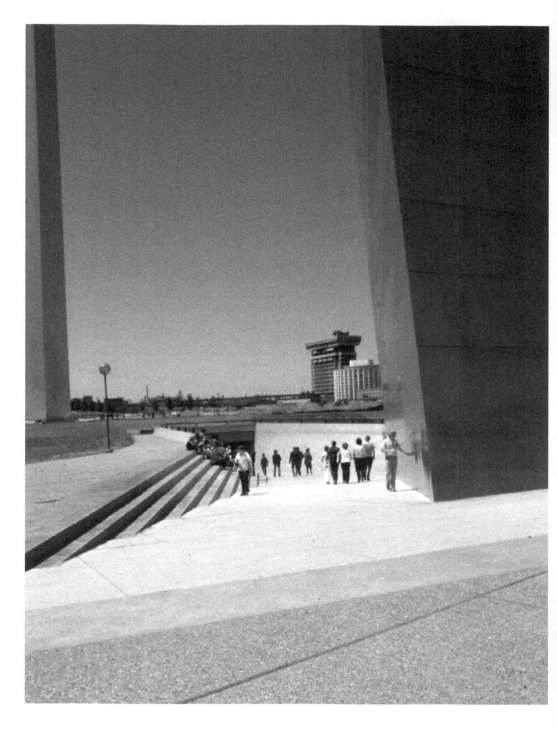

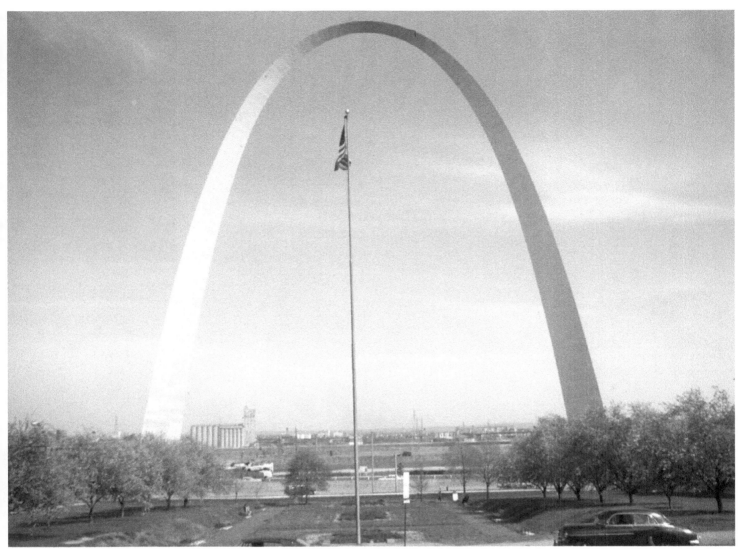

The steps of the Old Courthouse, which symbolized the rule of law during the nineteenth century, offered an outstanding view of the twentieth-century Gateway Arch.

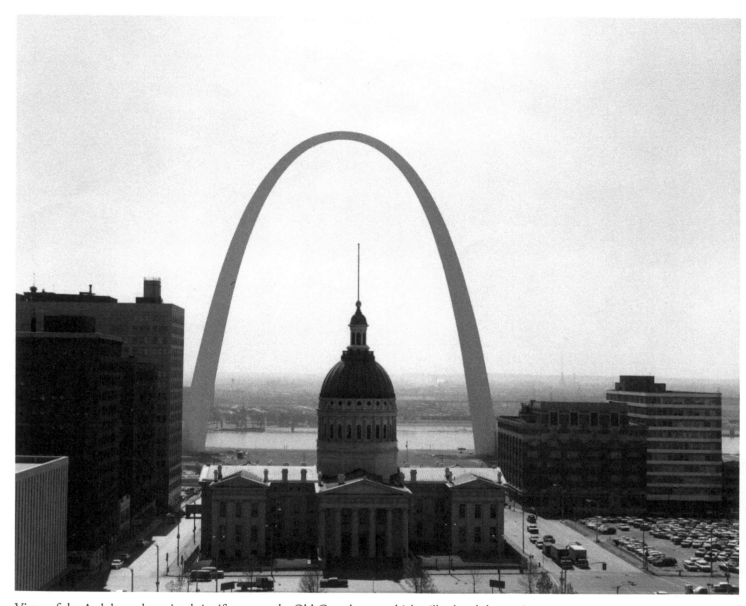

Vistas of the Arch brought a visual significance to the Old Courthouse, which still echoed the orations of Henry Clay, Stephen A. Douglas, and Thomas Hart Benton of a century before. After the National Park Service took ownership of the Old Courthouse in 1940, the coal dust was cleaned from its exterior and it was painted a glowing white.

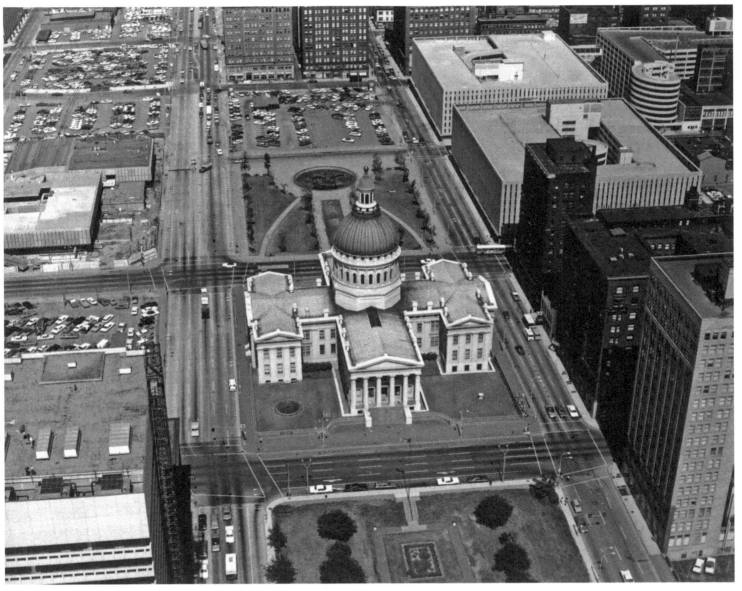

The view from the completed Arch offered new vantage points and vistas of downtown St. Louis—and disturbing realizations. When the riverfront memorial was first proposed in 1933, the streets of Downtown were thick with buildings. As part of the post–World War II fascination with the new and rejection of the recent past, blocks of Victorian-era and turn-of-the-century buildings were eliminated, only to make room for surface parking lots.

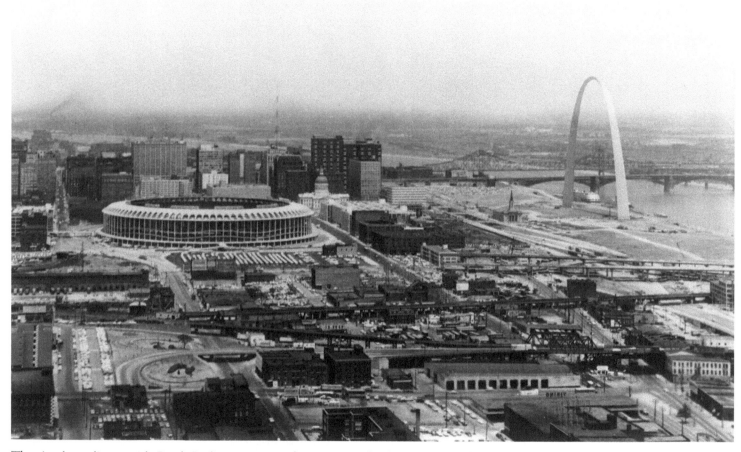

The circular, coliseum-style Busch Stadium was part of an 82-acre redevelopment west of the Memorial Grounds in downtown St. Louis. Edmund D. Stone, well-known architect in the modern style, designed the stadium. Its construction coincided with the construction of the Gateway Arch.

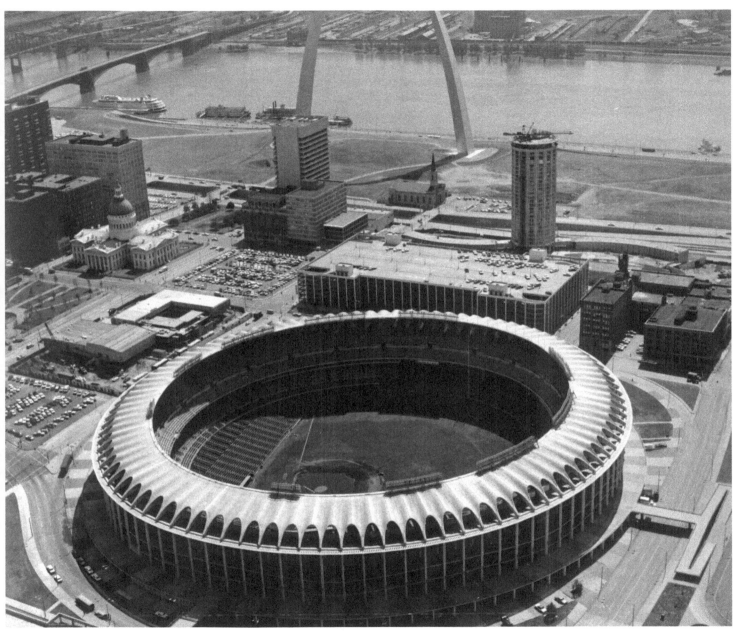

A series of graceful, catenary-style arches, reflecting the Gateway Arch itself, ring the roof of the new Busch Stadium, which opened in 1966. In the background, cranes are still at work atop the cylindrical Stouffer's Hotel.

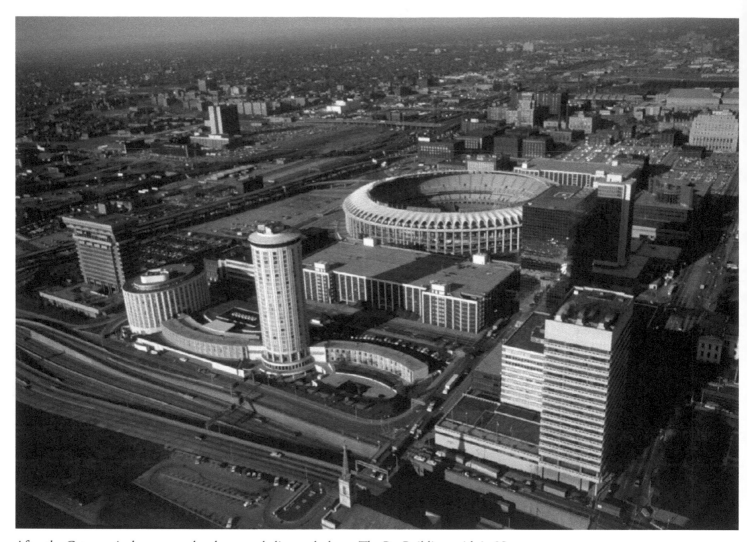

After the Gateway Arch was completed, a new skyline took shape. The Pet Building, with its New Brutalism style, was built at the southern end of Downtown. A revolving restaurant topped the cylindrical tower of a new, high-rise hotel constructed in 1966. The Gateway Tower filled the surface parking lot just southwest of the Arch in 1968.

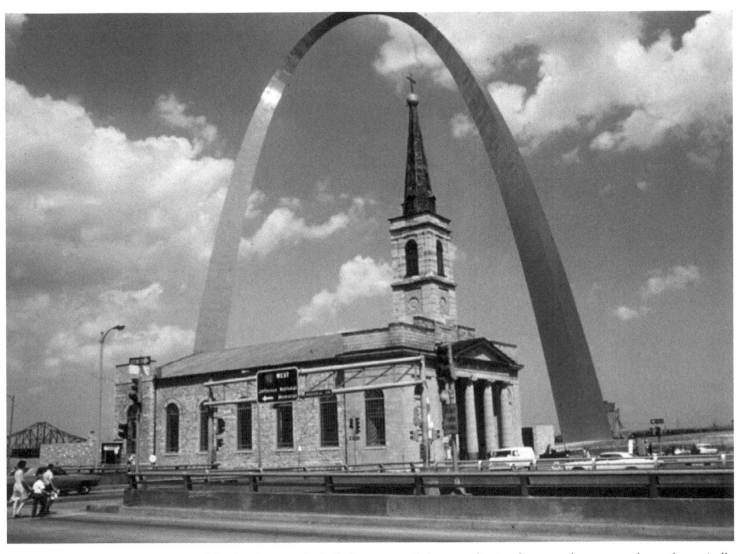

The simple, stone Cathedral, once crowded among the riverfront warehouses, stands out dramatically against the backdrop of the Gateway Arch. When Pierre Laclede founded St. Louis in 1764, he set aside this site for a church. Log church buildings were constructed on the site in 1770 and 1776. This Greek Revival–style building dates to 1834. The Old Cathedral stands on the only privately owned ground in the Jefferson National Expansion Memorial area.

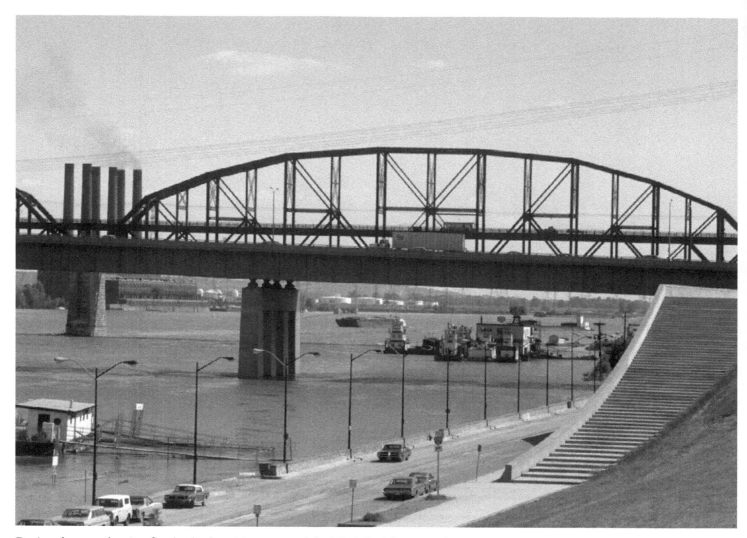

During the annual spring floods, the fast-rising waters of the Mississippi flow over the gangways to the showboats and excursion boats, cover the levee, and head for Wharf Street, which was renamed in honor of Leonor K. Sullivan, the St. Louis congresswoman who helped secure federal funding to complete the Arch.

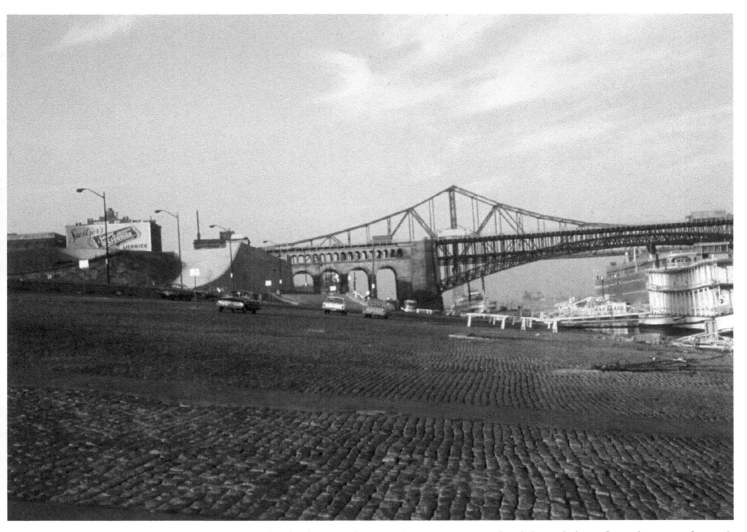

Pavers made of red granite from southeast Missouri surfaced the wide levee from the 1880s forward. In 1893, musician W. C. Handy slept under the Eads Bridge, on those pavers, during the two weeks he wandered St. Louis looking for work. Two decades later, Handy remembered that harsh experience when he wrote his classic "St. Louis Blues." Moored along the levee is the *Goldenrod* showboat, the largest showboat ever constructed. Built in 1909, it toured Misssissippi River towns before tying up in St. Louis. During the 1970s, the showboat continued to offer old-time melodramas, ragtime music, and festivals that drew crowds.

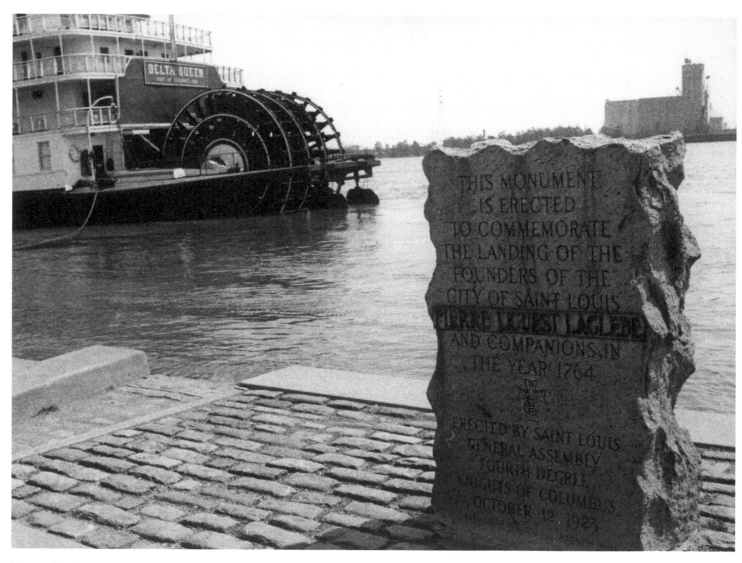

The *Delta Queen* is moored in this view near the site of the founding of St. Louis. An overnight passenger steamboat, the *Delta Queen* was built in 1926 in a shipyard in Stockton, California, to carry passengers in that state. Later, the sternwheeler was adapted for longer trips on the western river system. In 1942, the boat was fitted for service in the United States Navy. Following the end of World War II, she carried tourists on extended voyages along the Mississippi, visiting river towns as her nineteenth-century predecessors did. For years, the *Delta Queen* plied the waters of the Mississippi as the only operational boat still powered solely by steam, but is now docked at Chattanooga as a floating hotel, denied license by the U.S. Congress to resume river cruises.

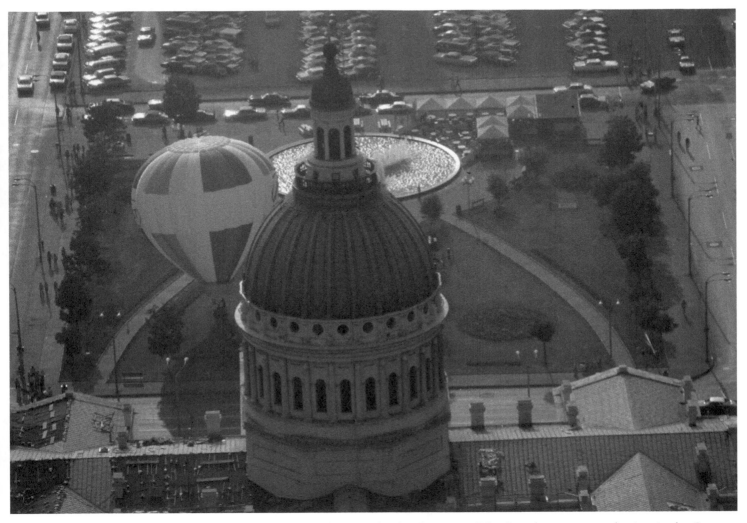

In this view, the city has completed a plaza west of the Courthouse as a puzzle piece in the Gateway Mall—a strip of green, public space, sculpture, and memorials that would eventually extend all the way from the Gateway Arch west to historic Union Station at the western edge of Downtown.

With the completion of the Gateway Arch, parades were routed along Fourth Street, past the front steps of the Old Courthouse, which had once been used as a reviewing stand for the Grand Army of the Republic.

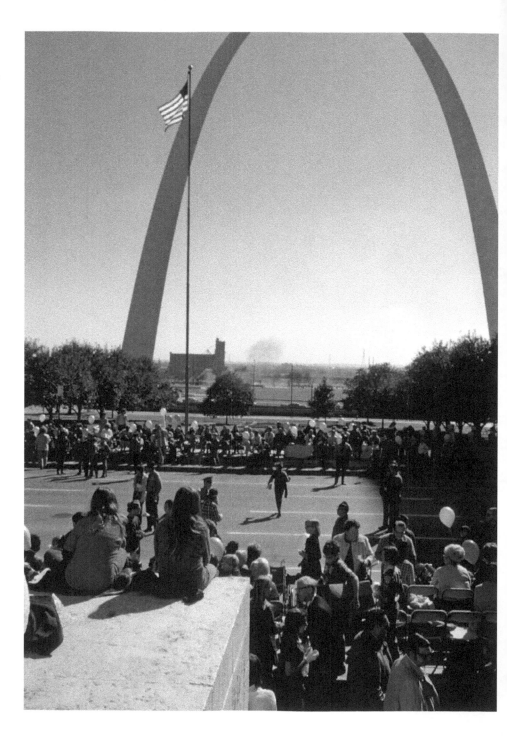

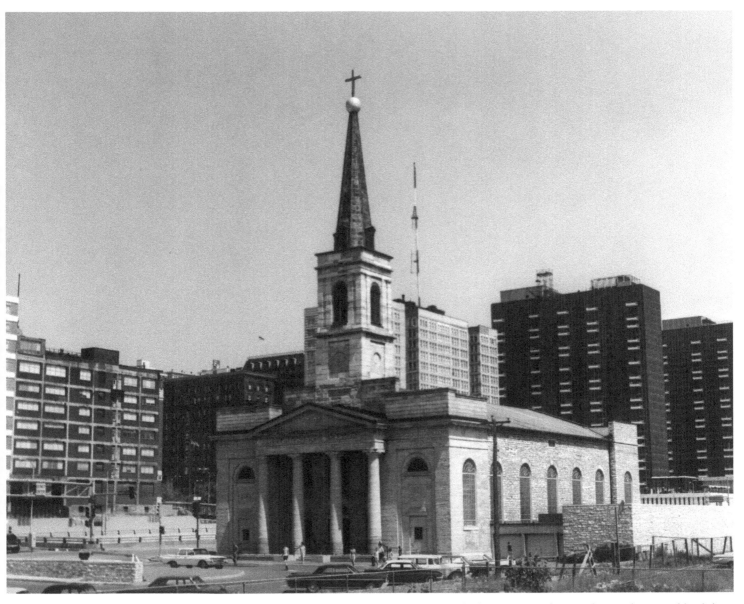

The towers of the Mansion House Center, apartment high-rises, provide a modern architectural backdrop for the classical architecture of the Old Cathedral. The firm of Schwarz & Van Hoefen designed the Mansion House Center, which was under construction while the Gateway Arch was being completed. When Eero Saarinen learned that the towers would exceed 300 feet in height, he increased the height of the monument from the original 590 feet to 630 feet. He was determined that the Arch should dominate its setting.

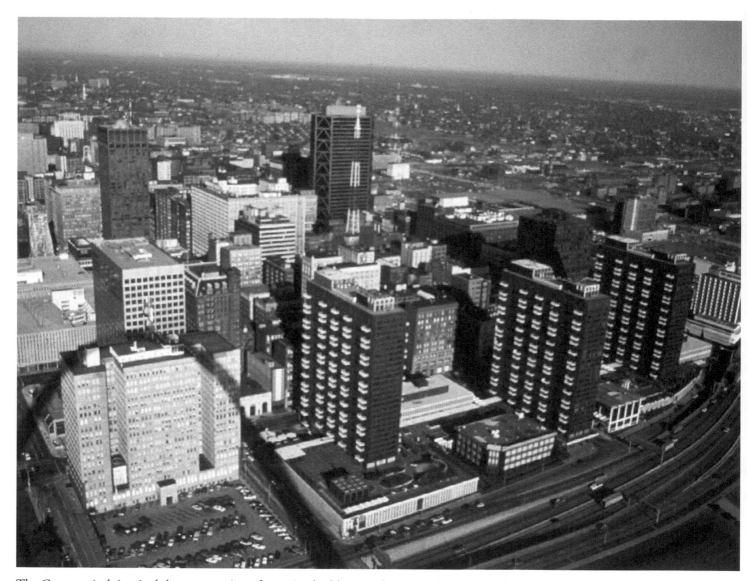

The Gateway Arch inspired the construction of towering buildings in downtown St. Louis and revitalized the district. The square, modern, dark-glass Laclede Gas Building (at top-left) stands at 8th and Pine streets. At 400 feet in height, it was the tallest building downtown when it was completed in 1969. The 35-story Mercantile Tower (to the right of the Laclede Building), built in 1976 at Washington Avenue and 7th Street, featured exterior K braces on each corner, marking its postmodern design.

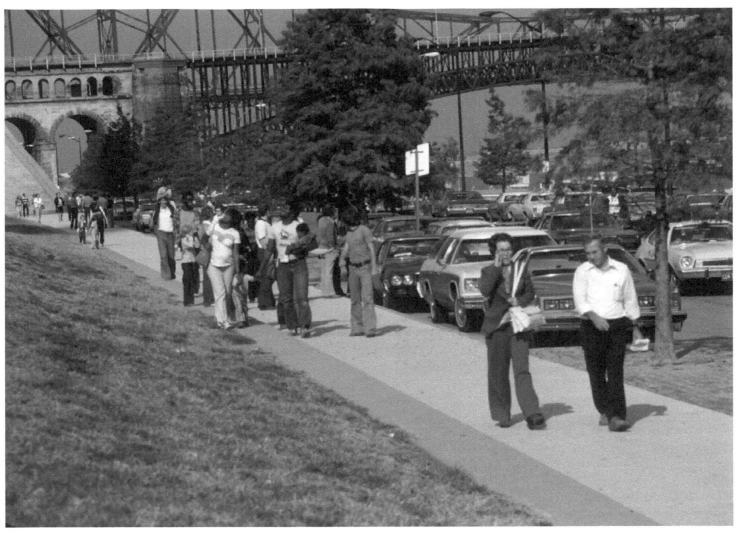

Roustabouts, immigrants, and entrepreneurs once walked along Wharf Street below the Eads Bridge. During the 1970s, tourists from across the nation and around the world strolled the St. Louis riverfront.

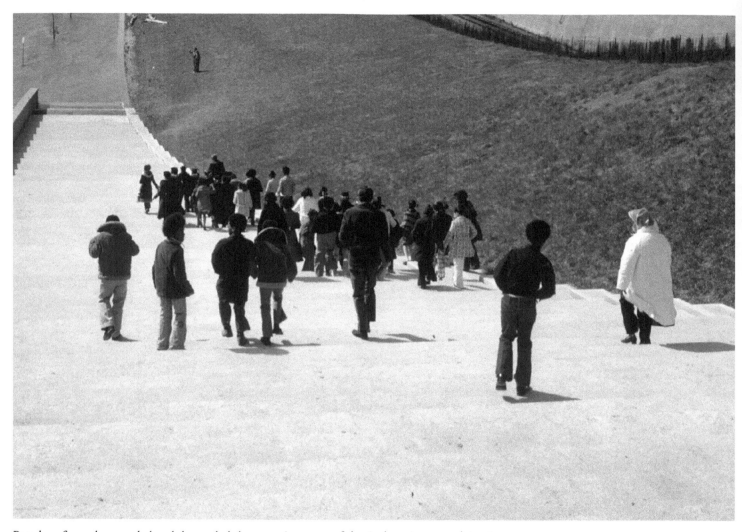

Parades of people ascended and descended the sweeping steps of the Arch, as it was evolving into a nationally and internationally recognized symbol. At the same time, it became a gathering place for St. Louisans.

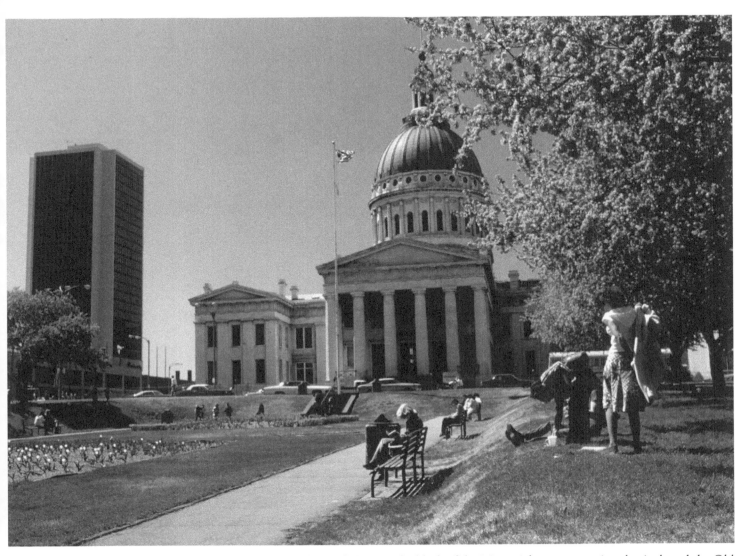

Luther Ely Smith Square, the block of the Memorial area connecting the Arch and the Old Courthouse, was named in honor of the civic leader who first envisioned a memorial. The square became a lunchtime destination for office workers brown-bagging it.

The graceful curve of the sleekly modern Gateway Arch enhanced the grace of the Renaissance-style dome of the nineteenth-century Courthouse.

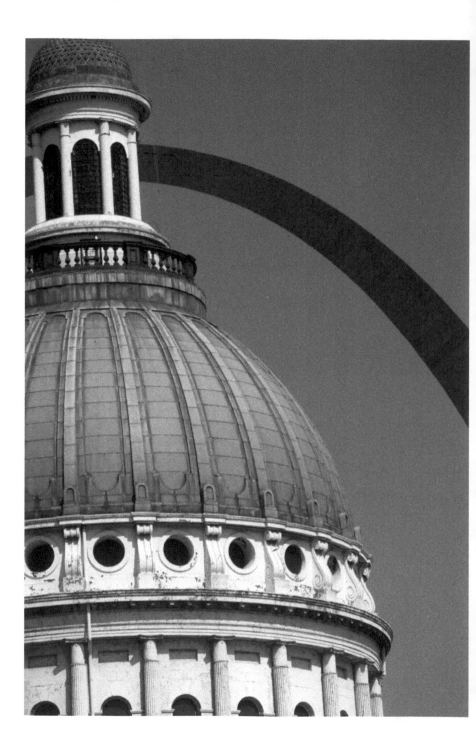

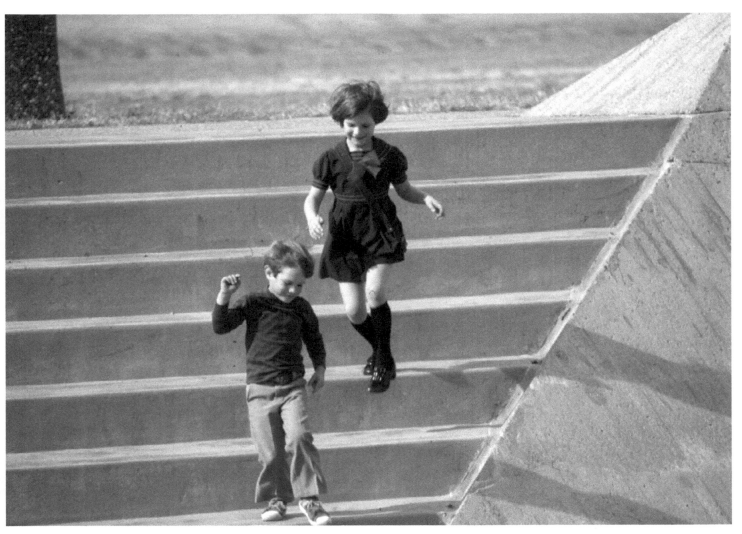

Children play on an architectural feature of the grounds of the Jefferson National Expansion Memorial, the stepped walls of the entrances to the Museum of Westward Expansion.

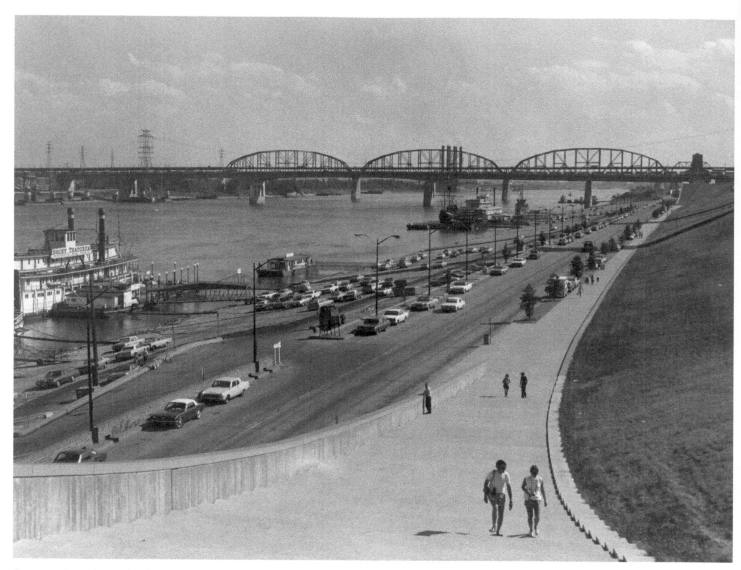

Streams of cars line Wharf Street. The flat-topped, new Poplar Street Bridge (officially the Bernard F. Dickmann Bridge) crosses the river in front of the Municipal Bridge, with its web of steel superstructure. The steps descending from the overlooks form a catenary curve like the Arch itself.

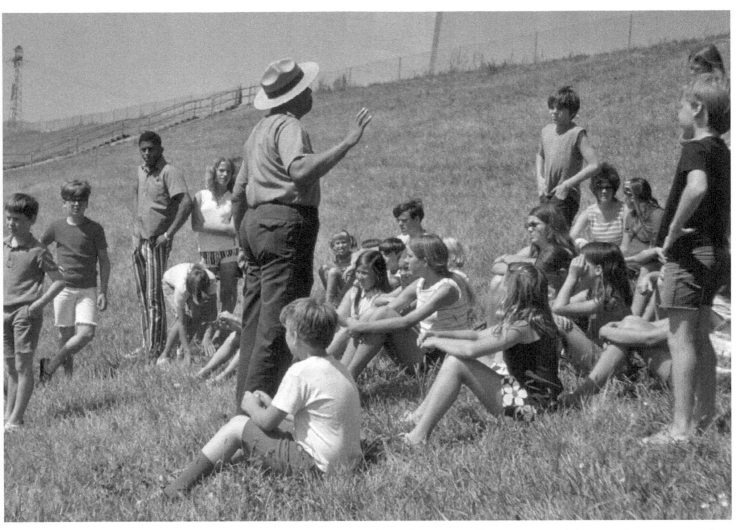

From as early as its conception during the 1930s, talks by rangers on history and nature were to be a centerpiece of a visit to the riverfront memorial.

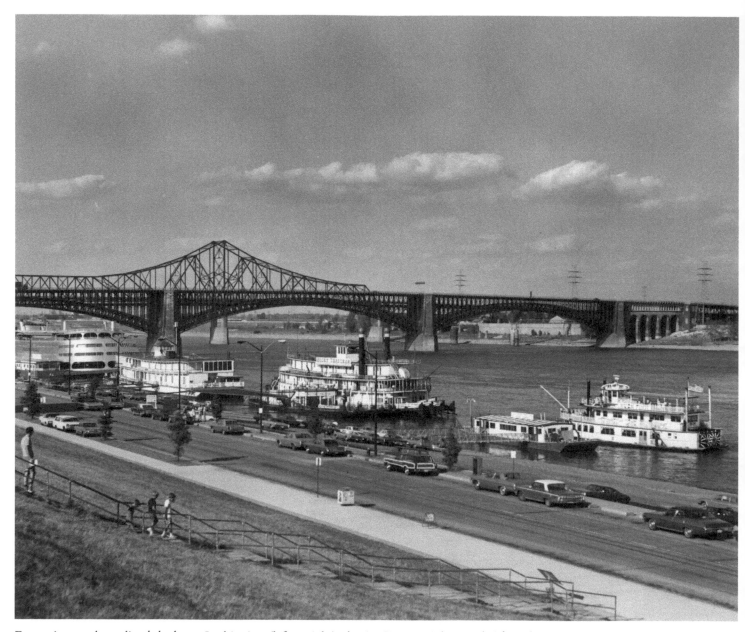

Entertainment boats lined the levee. In this view (left to right), the Art Deco, stainless-steel *Admiral*, the *Goldenrod* showboat, the *Becky Thatcher* excursion and dinner boat, and the *Huck Finn* excursion boat attract St. Louisans and tourists to the riverfront.

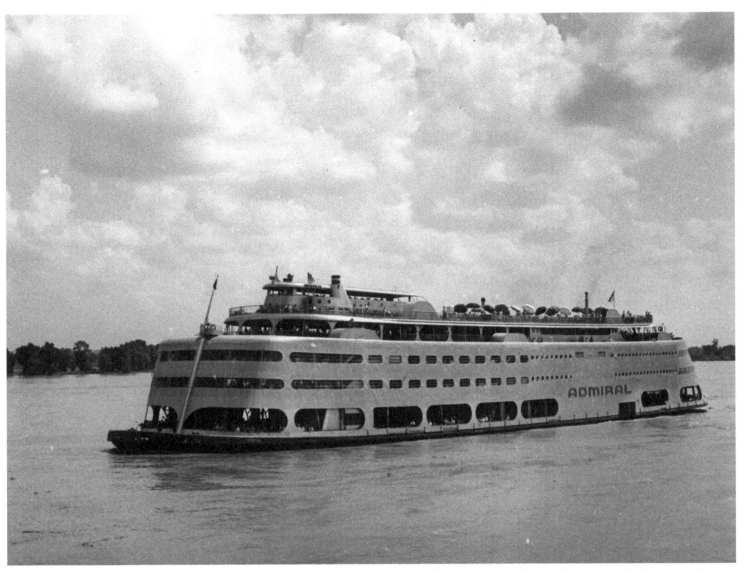

Advertising promoted the Art Deco *Admiral* as a "Palatial Excursion Steamer" and described it as "the Largest and Finest Inland Passenger Steamer in America, Completely Streamlined and Healthfully Air-Conditioned." As the first all-steel inland steamer and the nation's largest when it was built, the five-deck boat was 375 feet long and could accommodate 4,400 passengers. From 1940 to the 1970s, the boat plied the Mississippi at St. Louis as the most unusual and eye-catching passenger boat on the river. From 1979 forward, the riverboat was permanently moored and served as an entertainment venue and more recently a casino.

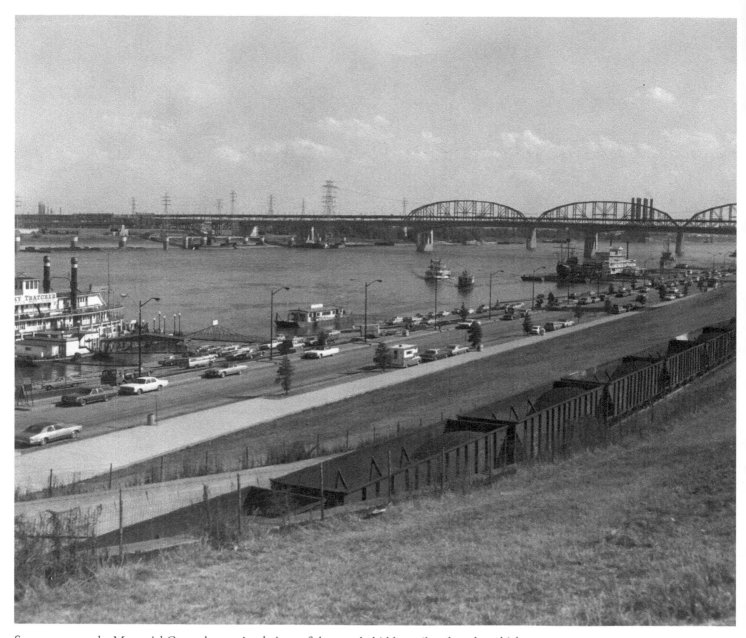

Some spots on the Memorial Grounds permitted views of the mostly hidden railroad tracks, which still carried freight along the riverfront. These cars are hauling coal up the river.

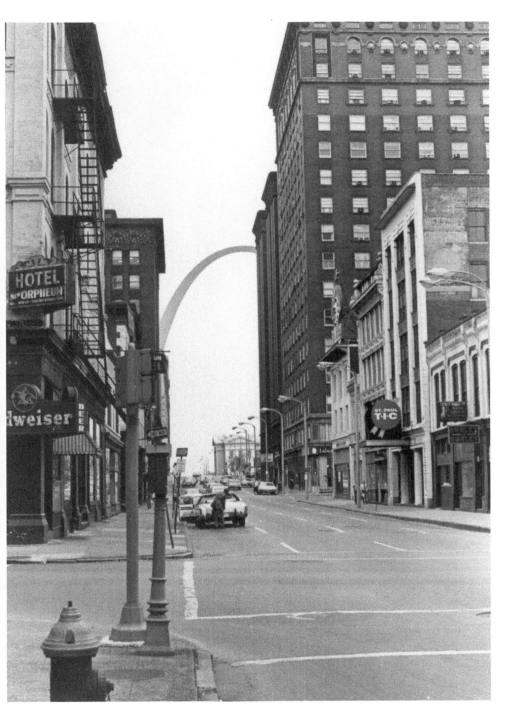

For a few years, the view of the Arch from Chestnut Street provided a rare juxtaposition of turn-of-the-century architecture and the dramatically modern Gateway Arch. Only the Wainwright Building (nearest the Arch, on the left) still stands. Designed by the great architect Louis Sullivan in 1891, the Wainwright Building is among the first skyscrapers in the world and is considered by historians to be one of the most important works in American architecture. The destruction of the skyscrapers on the right (the south side of the street)—the Buder Building (1903–1984) and the Title Guarantee (1899–1983)—stirred a debate about preservation and urban design that continues in the twenty-first century.

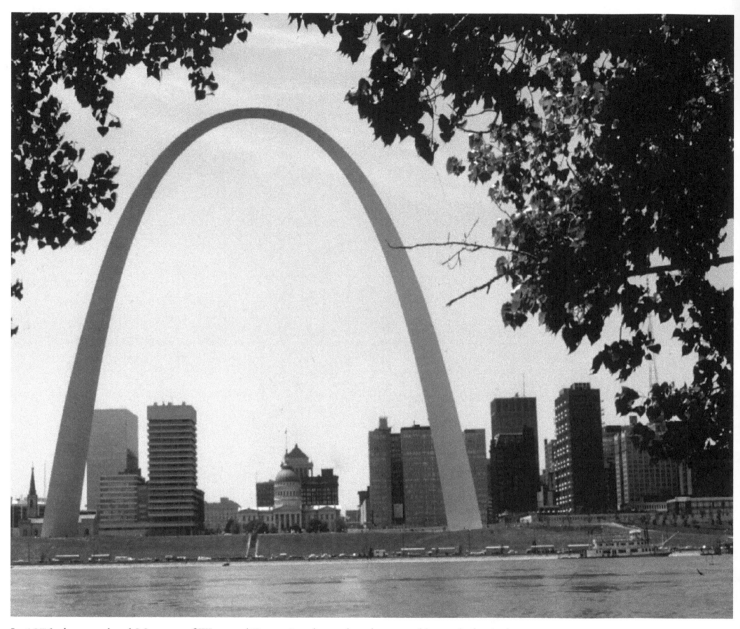

In 1976, the completed Museum of Westward Expansion, located underground beneath the Arch, was opened. The parade of school buses parked along Leonor K. Sullivan Boulevard reflects the popularity of the Memorial and its new museum for school field trips.

Notes on the Photographs

These notes, listed by page number, attempt to include all aspects known of the photographs. Each of the photographs is identified by the page number, a title or description, photographer and collection, archive, and call or box number when applicable. Although every attempt was made to collect all data, in some cases complete data may have been unavailable due to the age and condition of some of the photographs and records.

II **"Aeroplane" View of St. Louis**
National Park Service, Jefferson National Expansion Memorial

VI **The Old Court House**
National Park Service, Jefferson National Expansion Memorial

X **St. Louis City Directory, 1859**
National Park Service, Jefferson National Expansion Memorial

2 **St. Louis Riverside Illustration, Nineteenth Century**
National Park Service, Jefferson National Expansion Memorial

3 **Court House Lithograph**
National Park Service, Jefferson National Expansion Memorial

4 **Court House and Parade**
National Park Service, Jefferson National Expansion Memorial

5 **Levee at St. Louis, Emporium of the Frontier**
National Park Service, Jefferson National Expansion Memorial

6 **Elevated Railroad**
National Park Service, Jefferson National Expansion Memorial
VREF 017949

7 **Old Rock House Saloon**
National Park Service, Jefferson National Expansion Memorial
106-195

8 **Northeast Corner of Elm and First**
National Park Service, Jefferson National Expansion Memorial
106-880

9 **Warehouses on Third Street**
National Park Service, Jefferson National Expansion Memorial
106-5016

10 **The Michael Building at 207 North First**
National Park Service, Jefferson National Expansion Memorial
118-125

11 **The Garnier Building at 8 South First**
National Park Service, Jefferson National Expansion Memorial
118-130

12 **Wolfe-Hoppe House at 403-5 North First**
National Park Service, Jefferson National Expansion Memorial
118-128

13 **Commercial Palace at Third and Vine**
National Park Service, Jefferson National Expansion Memorial
106-5147

14 **Boatman's Exchange at 501-3 N. Wharf**
National Park Service, Jefferson National Expansion Memorial
118-131

15 **Bank Building**
National Park Service, Jefferson National Expansion Memorial
106-793

16 **Post Office and Custom House**
National Park Service, Jefferson National Expansion Memorial
106-5107

17 **River View of the Skyline**
National Park Service, Jefferson National Expansion Memorial
VPRI 004579

18 **Crowds at Demolition**
National Park Service, Jefferson National Expansion Memorial
No. 1192

19 **Autographing Bricks**
National Park Service, Jefferson National Expansion Memorial
106-4833

20 DEMOLITION ON WEST SIDE
OF SECOND
National Park Service,
Jefferson National
Expansion Memorial
106-5080

21 WRECKING BALL AT
SOUTH SIDE OF WALNUT
National Park Service,
Jefferson National
Expansion Memorial
106-871

22 RUBBLE NEAR COURTHOUSE
National Park Service,
Jefferson National
Expansion Memorial
106-xx74

23 OLD COURTHOUSE FROM
ROOFTOP
National Park Service,
Jefferson National
Expansion Memorial
PRI-03880

24 AERIAL FACING NORTH
National Park Service,
Jefferson National
Expansion Memorial
108-4838 2/23/1941

26 BREGER, HORNBOSTEL, AND
LEWIS DESIGN
National Park Service,
Jefferson National
Expansion Memorial

27 BAILEY DESIGN
National Park Service,
Jefferson National
Expansion Memorial
V 104000012

28 ARMSTRONG DESIGN
National Park Service,
Jefferson National
Expansion Memorial

29 MACKEY AND MURPHY
DESIGN
National Park Service,
Jefferson National
Expansion Memorial
folder 54

30 WALTER GROPIUS DESIGN
National Park Service,
Jefferson National
Expansion Memorial
Architects Collaborative
Walter Gropius
folder 71

31 KAHN PROPOSAL
National Park Service,
Jefferson National
Expansion Memorial
Louis Kahn
folder 15

32 SAARINEN ENTRY
National Park Service,
Jefferson National
Expansion Memorial

33 SAARINEN'S ARCH
National Park Service,
Jefferson National
Expansion Memorial

34 EERO SAARINEN
National Park Service,
Jefferson National
Expansion Memorial
Saarinen, Saarinen &
Associates
folder 56

36 AERIAL VIEW OF CLEARED
RIVERFRONT
National Park Service,
Jefferson National
Expansion Memorial
VREF 017954

37 ILLINOIS VIEW OF CLEARED
RIVERFRONT
National Park Service,
Jefferson National
Expansion Memorial
VPRI 004574

38 CLEARED RIVERFRONT
National Park Service,
Jefferson National
Expansion Memorial
VPRI 004704

39 AERIAL VIEW OF CLEARED
RIVERFRONT
National Park Service,
Jefferson National
Expansion Memorial
VREF 017944

40 SS ADMIRAL AND EADS
BRIDGE
National Park Service,
Jefferson National
Expansion Memorial
VPRI 006980

41 RAILROAD RELOCATION
GROUND BREAKING
National Park Service,
Jefferson National
Expansion Memorial
VPRI 004660

42 EXCAVATION SCENE
National Park Service,
Jefferson National
Expansion Memorial
VREF 017569

44 CONCRETE FORMS
National Park Service,
Jefferson National
Expansion Memorial
VREF 008620

45 FIRST STAINLESS-STEEL
SECTIONS
National Park Service,
Jefferson National
Expansion Memorial
Arch 4a

46 OBSERVATION DECK VIEW
National Park Service,
Jefferson National
Expansion Memorial
VREF 006120

47 RISING BY SECTIONS
National Park Service,
Jefferson National
Expansion Memorial
VREF 008602

48 CONSTRUCTION SCENE
SHOWING RAILROAD
National Park Service,
Jefferson National
Expansion Memorial
Arch 10a

49 CREEPER DERRICK
CONFIGURATION
National Park Service,
Jefferson National
Expansion Memorial
VREF 020229a

50 STEEL SECTION RISING
National Park Service,
Jefferson National
Expansion Memorial
VREF 008521

51 DERRICK DETAIL
National Park Service,
Jefferson National
Expansion Memorial
VREF 006168

52 VIEW OF SOUTH LEG
RISING
National Park Service,
Jefferson National
Expansion Memorial
Arch 2a

53 BOY SCOUTS AT
CONSTRUCTION SITE
National Park Service,
Jefferson National
Expansion Memorial
VREF 006186

54 LYNDON JOHNSON VISIT
National Park Service,
Jefferson National
Expansion Memorial
PRI-02941

55 THE VIEW FACING EAST
National Park Service,
Jefferson National
Expansion Memorial
VREF 008519

56 REACHING THE 530-FOOT
MARK
National Park Service,
Jefferson National
Expansion Memorial
Arch con 1

57 BRACING THE LEGS WITH
255-FOOT STRUT
National Park Service,
Jefferson National
Expansion Memorial
VREF 020240

58 CONSTRUCTION ZONE
PERSPECTIVE NO. 1
National Park Service,
Jefferson National
Expansion Memorial
8682a

59 CONSTRUCTION ZONE
PERSPECTIVE NO. 2
National Park Service,
Jefferson National
Expansion Memorial Arch
con 3

60 VIEW OF SKYLINE WITH
INCOMPLETE ARCH
National Park Service,
Jefferson National
Expansion Memorial
Arch con 2

61 ARCH SHADOW
National Park Service,
Jefferson National
Expansion Memorial
VREF 008838

62 STAIRCASE CONSTRUCTION
National Park Service,
Jefferson National
Expansion Memorial
VREF 008668

63 TWO CRAFTSMEN, OF
SCORES MORE
National Park Service,
Jefferson National
Expansion Memorial
VREF 006173

64 STAINLESS-STEEL
REFLECTIONS
National Park Service,
Jefferson National
Expansion Memorial
Arch 12a

65 VIEW OF ARCH AND
STADIUM CONSTRUCTION
National Park Service,
Jefferson National
Expansion Memorial
VREF 006160

66 PRECARIOUS
CIRCUMSTANCES
National Park Service,
Jefferson National
Expansion Memorial

67 PROGRESS AS OF SUMMER
1965
National Park Service,
Jefferson National
Expansion Memorial
Arch 14a

68 HARDHATS AT WORK
National Park Service,
Jefferson National
Expansion Memorial
Arch 6a

69 WALKWAY CONSTRUCTION
National Park Service,
Jefferson National
Expansion Memorial
VREF 006232

70 CRAFTSMAN ON STAIRCASE
National Park Service,
Jefferson National
Expansion Memorial
VREF 006261

71 MEETING OF THE LEGS
National Park Service,
Jefferson National
Expansion Memorial
VREF 020231

72 INSTALLATION OF THE
KEYSTONE
National Park Service,
Jefferson National
Expansion Memorial
VREF 020239

73 REMOVING SCAFFOLDING
National Park Service,
Jefferson National
Expansion Memorial
VREF 008698a

74 INSTALLATION OF THE
KEYSTONE NO. 1
National Park Service,
Jefferson National Expansion
Memorial
Arch 1a

75 INSTALLATION OF THE
KEYSTONE NO. 2
National Park Service,
Jefferson National Expansion
Memorial
Arch con 4

76 INSTALLATION OF THE
KEYSTONE NO. 3
National Park Service,
Jefferson National Expansion
Memorial
VREF 008532 asasa

77 INSTALLATION OF THE
KEYSTONE NO. 4
National Park Service,
Jefferson National Expansion
Memorial
Arch 13a

78 SEALING THE 144TH
SECTION
National Park Service,
Jefferson National Expansion
Memorial
VREF 006259

79 JOB WELL DONE
National Park Service,
Jefferson National Expansion
Memorial
VREF 008565

80 REMOVING MECHANISMS OF
CONSTRUCTION
National Park Service,
Jefferson National Expansion
Memorial
Arch 17a

81 PLUGGING THE HOLES
National Park Service,
Jefferson National
Expansion Memorial
VREF 008534

82 BUFFING AND POLISHING
National Park Service,
Jefferson National
Expansion Memorial
VREF 008621

83 FINISHING THE INTERIOR
National Park Service,
Jefferson National
Expansion Memorial
VREF 008460

84 VIEW FROM THE TOP
National Park Service,
Jefferson National
Expansion Memorial
VREF 008500

85 LEROY BROWN AT THE TOP
National Park Service,
Jefferson National
Expansion Memorial
VREF 008628

86 PHOTOGRAPHERS AT THE
TOP
National Park Service,
Jefferson National
Expansion Memorial
VREF 008525

87 OPTICAL ILLUSION FROM
THE TOP
National Park Service,
Jefferson National
Expansion Memorial
VREF 008549

88 MONUMENTS BY
COMPARISON
National Park Service,
Jefferson National
Expansion Memorial
VREF 005881

90 HUBERT HUMPHREY AND
OTHER DIGNITARIES
National Park Service,
Jefferson National
Expansion Memorial
VPRI 002487

91 LAST-MINUTE PLANS FOR
CEREMONY
National Park Service,
Jefferson National
Expansion Memorial
VPRI 002491

92 THE NATIONAL ANTHEM
National Park Service,
Jefferson National
Expansion Memorial
VPRI 02488

93 HUMPHREY AND PLAQUE
National Park Service,
Jefferson National
Expansion Memorial
VPRI 002485

94 WAITING OUT THE RAINS
National Park Service,
Jefferson National
Expansion Memorial
VPRI 002490

95 PERSONNEL IN RAIN GEAR
National Park Service,
Jefferson National
Expansion Memorial
VPRI 002495

96 FLOODED MUSEUM
National Park Service,
Jefferson National
Expansion Memorial
VPRI 002493

97 DIGNITARIES IN ELEVATOR
CAPSULE
National Park Service,
Jefferson National
Expansion Memorial
PRI-02954

98 A PEEK FROM THE
OBSERVATION DECK
National Park Service,
Jefferson National
Expansion Memorial
VREF 009695

99 ARCH PROFILE
National Park Service,
Jefferson National
Expansion Memorial
VREF 008871

100 SPACE-AGE EXPERIENCE
National Park Service,
Jefferson National
Expansion Memorial
VREF 014949

101 AN ARCH ODYSSEY
National Park Service,
Jefferson National
Expansion Memorial
VREF 008883

102 AFTERNOON SHADOW
National Park Service,
Jefferson National
Expansion Memorial
VREF 008849

103 WORLD WONDER
National Park Service,
Jefferson National
Expansion Memorial
VREF 009545

104 SLOPING CONCRETE
WALKWAYS
National Park Service,
Jefferson National
Expansion Memorial
VREF 012970

105 VIEW FROM THE OLD
COURTHOUSE
National Park Service,
Jefferson National
Expansion Memorial
VREF 008752

106 ARCH AND COURTHOUSE
National Park Service,
Jefferson National
Expansion Memorial
VPRI 004859

107 ARCHTOP VIEW OF
DOWNTOWN
National Park Service,
Jefferson National
Expansion Memorial
VREF 009531

108 BUSCH STADIUM AND
PANORAMA
National Park Service,
Jefferson National
Expansion Memorial
VPRI 004863

109 ARCH AND STADIUM
CATENARIES
National Park Service,
Jefferson National
Expansion Memorial
VPRI 004793

110 NEW SKYLINE RISING
National Park Service,
Jefferson National
Expansion Memorial
VREF 008938

111 OLD CATHEDRAL AND THE
ARCH
National Park Service,
Jefferson National
Expansion Memorial
VREF 008736

112 ANNUAL SPRING FLOODS AT
RIVERFRONT
National Park Service,
Jefferson National
Expansion Memorial
VREF 018037

113 COBBLE SURFACE OF LEVEE
National Park Service,
Jefferson National
Expansion Memorial
VREF 018038

114 DELTA QUEEN AND
FOUNDING MARKER
National Park Service,
Jefferson National
Expansion Memorial
VPRI 004546

115 GATEWAY MALL PLAZA
National Park Service,
Jefferson National
Expansion Memorial
VREF 009526

116 GATEWAY ARCH PARADE
National Park Service,
Jefferson National
Expansion Memorial
VREF 018185

117 MANSION HOUSE CENTER
AND OLD CATHEDRAL
National Park Service,
Jefferson National
Expansion Memorial
VPRI 004555

118 DOWNTOWN REVITALIZATION
National Park Service,
Jefferson National
Expansion Memorial
VREF 018212

119 STROLLING THE RIVERFRONT
National Park Service,
Jefferson National
Expansion Memorial
VREF 008265

120 DESCENDING THE STEPS
National Park Service,
Jefferson National
Expansion Memorial
VREF 013095

121 LUTHER ELY SMITH SQUARE
National Park Service,
Jefferson National
Expansion Memorial
VREF 017560

122 COMPLEMENTARY CURVES
National Park Service,
Jefferson National
Expansion Memorial
VREF 018025

123 CHILDREN AT PLAY ON
STEPPED WALLS
National Park Service,
Jefferson National
Expansion Memorial
VREF 008841

124 WHARF STREET PANORAMA
National Park Service,
Jefferson National
Expansion Memorial
VPRI 004578

125 RANGER WITH GROUP OF
VISITORS
National Park Service,
Jefferson National
Expansion Memorial
VREF 014952

126 ENTERTAINMENT BOATS
National Park Service,
Jefferson National
Expansion Memorial
VPRI 004583

127 THE ADMIRAL
National Park Service,
Jefferson National
Expansion Memorial
VPRI 004556

128 MEMORIAL GROUNDS
RAILROAD
National Park Service,
Jefferson National
Expansion Memorial
VPRI 004582

129 THE ARCH FROM CHESTNUT
STREET
National Park Service,
Jefferson National
Expansion Memorial
VPRI 004836X

130 ARCH SKYLINE WITH
SCHOOL BUSES
National Park Service,
Jefferson National
Expansion Memorial
VREF 008785

Printed in the USA
CPSIA information can be obtained
at www.ICGtesting.com
JSHW071631220424
61663JS00020B/118